PROFITABLE PORTRAITS

**THE PHOTOGRAPHER'S GUIDE TO CREATING
PORTRAITS THAT SELL**

Jeff Smith

AMHERST MEDIA, INC. ■ BUFFALO, NY

Published by:
Amherst Media, Inc.
P.O. Box 586
Buffalo, N.Y. 14226
Fax: 716-874-4508
www.AmherstMedia.com

Publisher: Craig Alesse
Senior Editor/Production Manager: Michelle Perkins
Assistant Editor: Barbara A. Lynch-Johnt

ISBN: 1-58428-152-9
Library of Congress Card Catalog Number: 2004101351

Printed in Korea.
10 9 8 7 6 5 4 3 2 1

Notice of Disclaimer: The information contained in this book is based on the author's experience and opinions. The author and publisher will not be held liable for the use or misuse of the information in this book.

Table of Contents

Introduction

When you think about the profitability of your studio, you probably think about marketing, pricing, overhead, etc. And, of course, these do impact the amount of money that ends up in your pocket. However, another important factor that might not immediately come to mind is style. With an off-target style of photography, you can struggle for each sale; with a well thought-out one, you can create images that sell themselves.

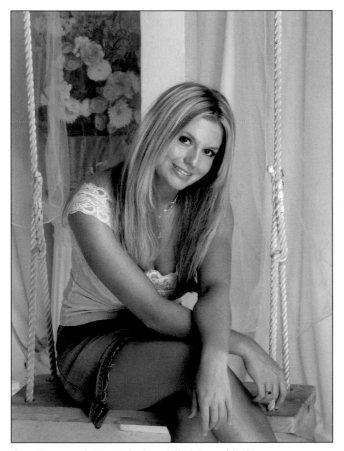

Creating a salable style is critical to achieving success as a photographer.

▷ The Impact of Style on Profitability

There are two styles of photography created by studios. There is the photography that the photographer likes to create and there is the photography that sells. Many photographers spend their entire careers trying to sell clients on images that were created to suit the photographer's tastes, not to fulfill the client's expectations. Successful photographers, on the other hand, determine what sells and then learn to enjoy and improve on the style of photography that sells to their clients.

That may sound easy, but it's not—and that's why I wrote this book. In it, we'll explore how to determine what it is your clients want, as well as how to create it in your photographs—and create it consistently. Creating a successful style means taking control of your business and making conscious decisions

based on what you need to do to create salable images. This includes: your choice of equipment; your decisions about lighting, posing, clothing, and background selection; and the decisions you make about your studio's marketing and appearance.

If you follow through on these steps—analyzing your unique market and making decisions designed to create the product that's best suited to it—you'll be amazed at the difference it will make, both in your customers' satisfaction *and* your bottom line!

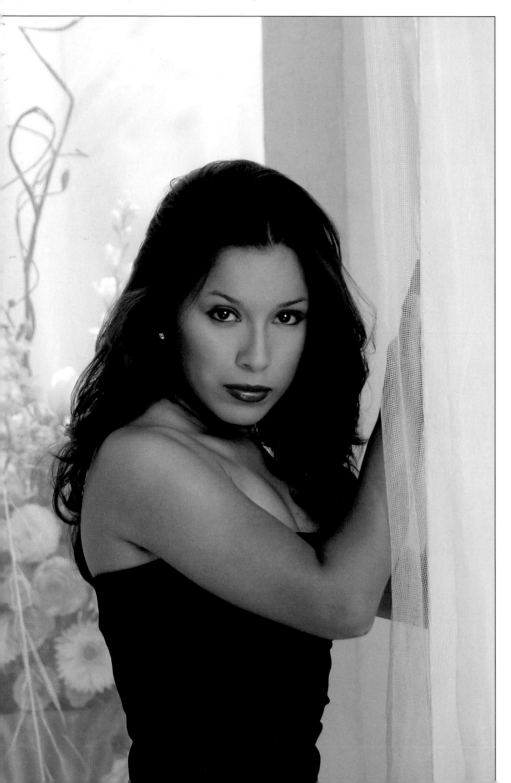

I started in photography at a very young age. I knew that I wanted to be a photographer when I was fourteen, did my first wedding at the age of sixteen, and opened the studio I have today at the age of twenty. I was either ambitious or crazy.

As a mere baby in this business, the one thing I kept hearing from older photographers was that I needed to develop a "style" of photography. When I asked these all-knowing gurus of photography how you developed such a "style," they shrugged their shoulders and said, "It just happens." Through the early stages of my career, no one seemed to be able to pin down and explain to me how to develop this much-discussed style. The photographers I spoke with either had one and didn't want to share the secret or couldn't explain the process. I felt like a little kid who asks his parents about sex and hears in reply the stuttering and rambling of two people who don't know how to explain it. They *knew* what it was (after all, you were here), but they just couldn't put in into words. Photographers were the same way—they had a style, they just couldn't explain to me how I could get one of my own.

After twenty years in this business and writing books on everything from posing, to digital techniques, to business practices I thought it was high time to answer that question. How

Developing a profitable style means making a lot of conscious decisions—decisions about lighting, posing, clothing, styling, and much more.

exactly do you define or refine your photographic style? (And just in case you are wondering, no, it *doesn't* just happen!)

Do you want to be a style copier and trust your fate to someone else's ideas, or do you want to be a style creator, and develop a unique style that really works for you and your clients?

▷ Style Creators vs. Style Copiers

One thing I have noticed in my time in this profession is that there are two types of photographers: creators and copiers.

Copiers. Copiers are like photographic style sponges. They seek out photographers who are creators and they soak up or adopt their photographic style. I see this every year when I go to the Senior Photographer's International convention. Among this group, Larry Peters has been "Mr. Senior Photography" for years. He shares his ideas with thousands

of photographers each year—and when you look at the folio competition, you can see Larry's influence throughout. Copiers have seen his work, learned from him, and adopted his style as their own.

Of course, all of us start off as copiers, but some photographers never get past this point. They go to a class or seminar given by a photographer whose work they admire and all of a sudden they own every piece of equipment demonstrated at the show. Their photographic style is longer what it was—they've become the instructor's "Mini Me." This lasts right up until

Everyone starts out as a copier, but at some point the creators start holding onto their own style. They develop a unique way of photographing clients that makes their work recognizable to anyone who views it.

The downside of copying is that you put someone else in control of both your style of photography and the success you will enjoy in life.

Creators. What separates the copiers from the creators is that, at some point, the creators start holding onto their own style. They are photographers who have developed a unique and consistent way of photographing clients—a way that makes their work recognizable to anyone who views it. Whether the photograph is taken in the studio or outdoors, there is a common style that ties all the images together. This goes beyond lighting and posing. These photographers have taken control of their images from start to finish and have made conscious decisions about every element in every photograph. If something is in the frame of a portrait, they wanted it to be there in order to produce the desired look or style.

They continue to learn from other photographers, but what they learn is added to what they already know. This is the way a photographer's personal style begins to be defined. While the copiers just keep reinventing themselves with each seminar, class, or book they read, the creators builds a consistent, successful style that makes their work stand out.

the next photography seminar with a really impressive speaker. Then the copier has a new style of photography to offer his or her clients.

It should be noted that there are some very successful copiers. In copying the *style* of a successful photographer, they also hope to copy the *financial rewards* that photographer has achieved. Sometimes this works. Many speakers lay out a blueprint for their past success for the copiers of the world to follow. If you follow that blueprint, live in the right area, and changes in the world don't make the blueprint obsolete, you could even enjoy some of the same success as the creator photographer.

▷ Why What Works for Others Won't Necessarily Work for You

Back in the day when I was a budding copier, I looked for a style of photography—as well as a way to pay my bills. I was young, and when I went to a seminar I bought into the photographer's ideas hook, line, and sinker. This was the '80s—greed was good and every-

one started to measure a person's worth by their job and the car they drove. It was the decade that gave us such glorified titles as "sanitation engineer."

The '80s also brought about a new type of photography called boudoir photography. That's right—woman were flocking to photography studios in droves with their lingerie in hand to have seductive portraits taken for the man in their life. According to the speakers of the day, these ladies would buy thousands of dollars worth of portraits, because they made them look so unlike their "real" selves—"Mrs.

Everyday Housewife" magically turned into a cover girl with very few clothes on. The concept sounded good, so I designed new sets, studied the videos and books, purchased lingerie in various sizes, and started advertising. I was ready for the money to start rolling in.

Although I followed the blueprint for success down to the letter, I ended up photographing younger women (21–25) who were holding down a minimum-wage job while waiting for the next Mr. Right Now. I would spend two hours on a session to make them look beautiful and they would buy a 5 x 7-inch print and eight wallets (only because they couldn't buy a single wallet). For all my work, I received the sitting fee and a $100 order. It was a far cry from what I was expecting.

There were two important factors that I hadn't considered. First of all, in business, what works well in one area doesn't necessarily work in another. There are differences in clients' tastes and beliefs, the population of the city or town, as well as countless other factors that make an idea work in one area and not in another.

The second consideration was that photographers who put on programs need to fill seats. They fill seats by show exciting new ideas and concepts. The only problem is, the ideas and concepts are often more exciting for the photographers than the photographer's clients. Often you hear photographers say, "You don't sell many of these, but they sure are fun to take!" This type of thinking is why so many photographers end up divorced or broke or both. If an image doesn't sell, why take it? This isn't a *hobby,* this is a *profession.*

In business, what works well in one area doesn't necessarily work in another. There are differences in clients' tastes and beliefs, the population of the city or town, as well as countless other factors that make an idea work in one area and not in another.

If you let your ego convince you that you know what's best for your client, you'll quickly discover your mistake—probably as you watch a client walk out of your studio with their money still in their pockets.

▷ What Clients Thought of Some of My "Great" Ideas

Here are just a few ideas I heard at programs I attended and what *my* clients thought of them. Of seniors in swimwear, clients exclaimed, "Cheesecake at seventeen, isn't that illegal?" or "If I wanted my daughter to look like a streetwalker I would have told you!" Extreme wide-angle portraiture also got some poor responses: "The background is beautiful, but I can hardly see my daughter!" or "If I wanted a picture of greenery, I would have bought a poster!" I have tried many ideas during different stages of my business—things that seemed like a great idea at the seminar but flopped when I tried them at home. This is the biggest danger of never going beyond copying. You are relying on photographers who know nothing about your business or your potential clients to guide and direct your studio. To me, this was much scarier than making the jump from copier to creator.

▷ Overcoming the "Artist" Mentality and Getting Down to Business

Ego is another important factor in defining or refining your photographic style. Some photographers tend to develop an "artist mentality" two weeks into their first junior college photography class. "I am the artist," these misguided people think, "and I will tell the client what is good!" This usually lasts right up until they are confronted for the second or third time by a client who asks, "What were you thinking taking this portrait this way? I could have taken a better picture at home with my little digital camera!" As the client leaves the studio (with their money still in their pockets), it suddenly becomes clear that there *is* a higher authority.

Creating the kinds of images that sell—the images that *clients* like—will take some focused practice. As I tell my young photographers at the studio, you can practice to be good or you can practice to be bad. That sounds like a simple statement, but I've watched

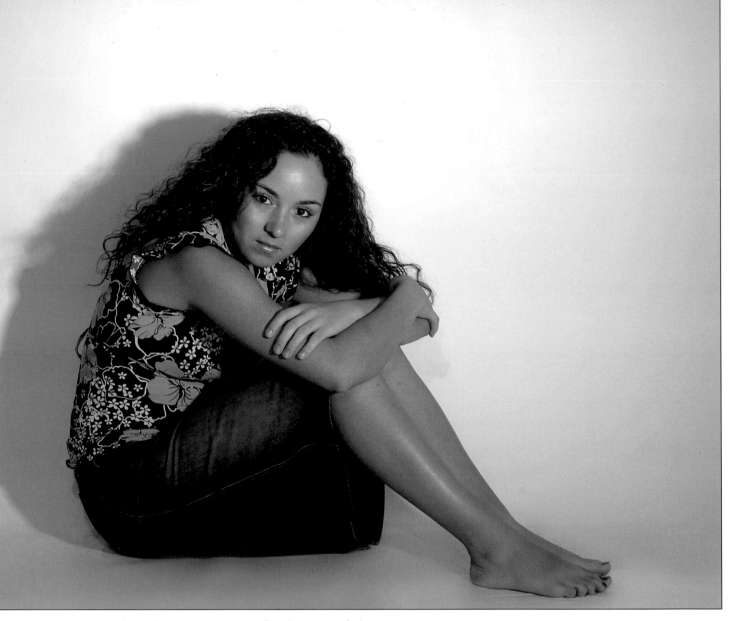

photographers doing test sessions for the type of photography we are working with in the studio, and I've seen them acting like they are in high school and encouraging their friends to act goofy. When you work on developing your photographic style, you need to practice the work you are going to create for your clients, not the work that you would do if photography was your hobby. Once again, you can practice to be good or practice to be bad.

I am not saying that you should "sell out" (which is usually what my young photographers say when I suggest they harness their "enormous talent" and learn how to create portraits the client will actually buy!). I do suggest, however, that if you want to cre-

If you tailor your style to your market, you will make much more money and you will avoid a life of frustration trying to sell people something they do not want.

ate photographs according to your own tastes, you get a job and make photography your hobby. You will make much more money and you will avoid a life of frustration trying to sell people something they do not want.

The point of this book is not to give the copier yet another style to copy but to help the copier become a creator with their own style that is based on their clients' expectations. This is the key to a successful and profitable career in photography.

1. Equipment Choices

Film or digital, telephoto or wide-angle, Photogenic or Norman, Canon or Hasselblad—my question is, does it matter? Equipment has nothing to do with your style, because the image is created in your mind, not the camera. Your photographic style is based on what you know, not what you photograph with.

Many young photographers think that a certain camera, bigger lens, or better lighting will improve their images and be a factor in their style. However, equipment won't make you a better photographer, only practice and careful decision-making will do that.

▷ Film vs. Digital

Tools or Gadgets? We will start with the question everyone has been asking for the last five years: film or digital? The choice of film versus digital is a business decision, not a creative decision. Many photographers would argue with that, explaining all the creative possibilities that digital offers. However, you have to ask yourself if the effects and the creative options you have with digital are tools that help you perfect your photographic style or just gadgetry that should have nothing to do with it.

Added Options Mean Added Costs. I remember the first time I saw a person demonstrating the corrections that were possible with digital files. The

You can buy the most expensive, sophisticated equipment on the market and it won't make you a better photographer. Only careful decision-making will do that.

Sure, you can correct just about any problem with Adobe Photoshop—but it isn't it more efficient to make sure you're taking the best possible image in the first place?

image was a full-length bridal portrait, with the woman shown holding her veil with each hand. The hands were exactly the same on each side of the body and were perfectly symmetrical. The person doing the demonstration explained that the image would be better if the one arm was bent with the hand coming upward, while the other arm stayed extended down.

The fact that digital made this correction easier is all fine and good, but shouldn't the photographer have posed the bride properly in the first place? Also, who paid for the time to remove this young bride's arm and reposition it? As one of the characters in *Jurassic Park* said, "You got so caught up in what *could* be done that you didn't think if it *should* be done!"

Many photographers are struggling with this right now. Digital has given us so many options, but each one of them takes time—time that has to be paid for. Many photographers who switched from film to digital now make *less* profit in their business and spend much *more* of their free time fiddling with image files

(rather than being home with their family and enjoying life). I am not against digital— my own studios are *completely* digital—but you have to look at it as a businessperson and find a way to make it as profitable as film. This leads me back to my original statement that the choice of digital or film is a business question and not a determining factor in your photographic style. To learn how to make digital profitable, read my book *Professional Digital Portrait Photography* (Amherst Media, 2003).

Getting Over the "I'll Just Fix It in Photoshop" Mentality. Enhancements and corrections have always been possible. Although they are easier with digital, they are still expensive—whether in terms of time or money. Enhancements and corrections (other than simple retouching for acne and other blemishes) shouldn't need to be done if you know what you are doing. If you can't get it the way you want it on film or in your digital file, you need to quit spending so much time fiddling on the computer and work on developing your photographic style.

▷ Cameras: Tools, Not Status Symbols

Does Brand Really Matter? Is your photograph shot with a Hasselblad any better than my photograph shot with a Bronica (when I used film)? Is my photograph shot with a Canon 10D inferior to one taken by another photographer who shoots with a Mamiya and a digital back? The answer to these questions is that it depends on the photographer. You can take the most expensive camera in the world and put it in the hands of a mediocre photographer and you will have mediocre photographs that can be enlarged to make very big prints! You can take the oldest, ugliest camera in the world and give it to a skilled photographer

If your client likes and purchases the image, does it matter what kind of camera you used to create it?

and he or she will create beautiful images. Now you might not be able to enlarge them to any degree, but the image quality will be beautiful.

What I am saying is that the pieces of equipment we use are just tools. They won't make you a better (or for that matter, worse) photographer. They capture an image and that's it. As long as you know how to use the one you're shooting with—whether it's digital or film, and whatever brand name is inscribed on it—the camera won't matter.

Buy What You Need (Not More or Less). Still, many photographers make the mistake of looking at their cameras as toys, not tools. When I buy a camera (and, for that matter, any equipment) I look for the cheapest camera that will hold up to the heavy work

load in my studios and allow me to produce images of the size that I sell to my clients.

Let me explain. I photograph seniors, and the largest prints I sell are 20 x 24 inches. Knowing this, when we went digital I selected the most economical camera to fill the job needed: the Canon D30. There were two other cameras on the market that were similar (a Nikon and a Fuji), but the Canon was the least expensive—plus I already had Canon lenses. As digital cameras have evolved, file sizes have actually become larger than we need to create the biggest prints we sell in my studio. I know photographers who photograph seniors using a digital back that can produce images that are much larger than they would ever sell to a client. To me, that is throwing money away on *toys*, not wisely investing in *tools*. You can get emotional when you buy a car—that's a personal thing. A camera, on the other hand, is a piece of business equipment that will wear out, drop dramatically in value (especially with digital), and be discarded when the newer models come out.

▷ Lenses

Does Brand Matter? I'm on a roll now, so let me further upset all you young photographers who have maxed out your credit cards to get the latest and greatest camera; let's talk about lenses. As they say, a picture is worth a thousand words. In the following photographs, you will see four images, one taken with a Canon Lens, one taken with a Sigma Lens, one with

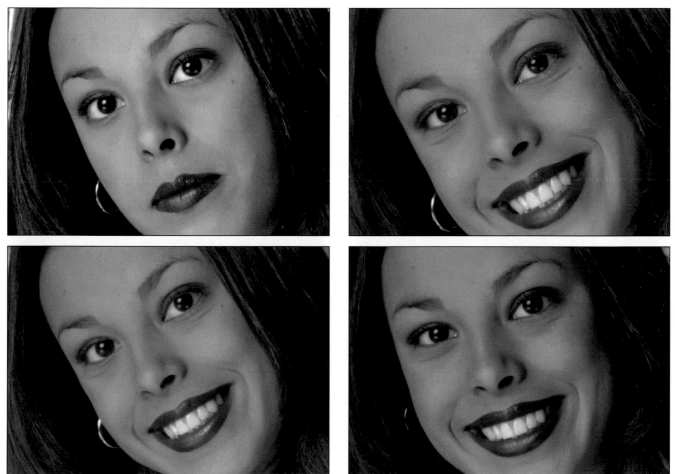

These images were taken with Canon, Tamarom, Sigma, and Tokina leses—all of which were the newest version of the same size zoom lens. The photographs were not color corrected or retouched. The files were enlarged to 20"x24" and cropped to show just the face area. Is the differences between the images significant to you? If not, why would you buy the most expensive lens when a cheaper one will do the job?

a Tamron, and the other taken with a Tokina. They were enlarged to 20 x 24 inches and just the facial area is shown here. Do you see much difference? If you do, you have better eyes than I do! Although photographers will tell me there is a difference, if I can't see it, I seriously doubt my clients will. Enough said.

What's Actually Important: Focal Length. More important than the *brand* of the lens is the *size* of lens you use. Some photographers select a lens based on the working distance they want between the camera and the subject (for example, I see photographers working outdoors with a normal lens because it allows them to work closer to the client). Some photographers, on the other hand, use a huge a telephoto for no other reason than it looks cool.

The proper way to select a lens is to decide how you want the photograph to look and then select the lens that will achieve that look. As a result, I never use

a "normal" lens; a *normal* gives you a *normal* perspective and a *normal* overall look. Using a normal focal-length lens gives you the same look that people are used to seeing in the candids they take at home—and people won't pay (or at least won't pay *as much*) for portraits that look normal in any way. Normal lenses also affect a person's appearance in ways that aren't pretty. Typically, the nose appears larger and the person's head looks slightly distorted.

The lens of choice for almost all photographers is a portrait lens (hence the name). The portrait lens (100mm–135mm for 35mm cameras and 110mm–165mm for medium-format cameras [for digitals, use the equivalent focal length, taking into account the focal-length factor for your model]) gives you the best perspective for creating a sellable portrait. This lens isolates the subject, putting the foreground and background out of focus. This adds impact to the subject

Focal length controls perspective and is an important consideration when choosing a lens.

The best way to produce a soft background is to use a portrait lens with a wider aperture (or the subject positioned father from the background).

in mind: *you* are in control of the background you use. A beautiful background adds to the overall look of the portrait, so if you find you have to use a long telephoto to throw an ugly background completely out of focus, you're probably better off moving to a more attractive spot to create your portrait.

A better way to control the softness of a foreground or background is to use a portrait lens and adjust the aperture or subject position. To adjust the depth of field with the aperture, select a larger or smaller setting. The larger the opening of the lens, the softer the foreground and/or background; the smaller the aperture, the greater the depth of field. If you normally shoot at f8 and you want to soften the background and/or foreground, open up the lens to f5.6 or f4. If you want to show more detail in the background and/or foreground, change from f8 to f11 or f16. To further control the softness or clarity of the foreground and/or background, reposition the subject. If you want to soften a background, pull the subject further from it. To increase the clarity of background, move the subject closer to it.

while adding a feeling of depth. From the softer foreground, the image grows progressively sharper as it approaches the subject, drawing the viewer's eye into the portrait. The background falls further and further out of focus the farther from the subject it gets. This gives the illusion of the photograph having a third dimension.

Large telephotos look cool to the photographer but are rarely used. These lenses (250mm–400mm on a 35mm camera, 300mm–500mm on a medium format) have a very shallow depth of focus. If you want a very distracting background to go completely out of focus, the larger telephotos are perfect. But keep this

▷ **Lighting**

Does Expensive = Better? Now, let's talk about lighting. To keep this as short as possible and show how "important" expensive lighting and lighting modifiers are, I took a series of photographs (next page) using different brands of lighting (Photogenic, Alien Bees, Broncolor). I then used three types of light modifiers (umbrella, Starfish, white wall) to bounce the light

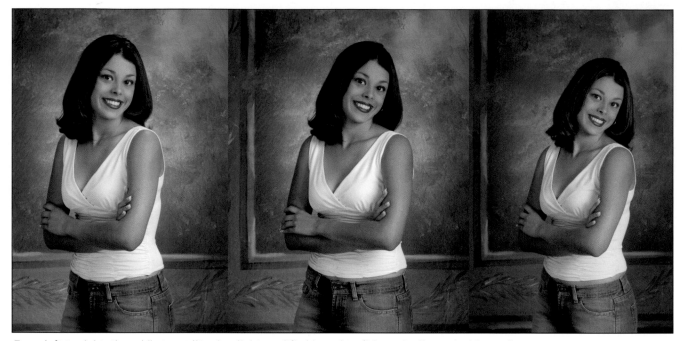

From left to right, the subject was lit using light modified by a Starfish, umbrella, and white wall.

off. As you look at these images, do you notice any difference in quality? Does the more expensive brand of lighting make this young lady any more beautiful than the less expensive brand of lighting does? What about the light modifier? Does the white wall (although lacking the control of the other two) make the young model appear less perky than the images created with the more sophisticated light modifiers? I think not.

Color Balance. Naturally, certain lighting equipment can make your life easier—especially in a larger volume studio. Lighting for digital photography, for example, is easier if you work with a single brand of lighting in each camera area. Each brand of lighting produces a unique color of light—they may all be close, but they're never exactly the same. For this reason, white balancing your digital camera is much easier when all the lights produce the same color. I have twelve shooting areas and just about every light known to man. To make my life easier (and avoid having to purchase more lighting), I grouped the same brand of lights together in each camera area, creating a consistent color within that area. This can also work

with a smaller studios—simply group the same brand of lighting for your main and fill, then use the other brands of light as your hair and background lights. This way, all the lights that determine skin tone will produce the same color temperature.

▷ **Make Purchases Based on Results**
Equipment should be selected to achieve the desired results. Don't select a lens (or a light, or a camera, etc.) because it looks cool or because it's the one used by another photographer. Select the equipment you need to achieve the results you are looking for. This is the beginning of developing or refining your own photographic style. You decide—let me repeat that—*you decide* how to use *your* equipment to achieve the result *you* want. This type of thinking is what separates the few creators (who control everything in their images) from the many copiers (and the photographers who just don't care).

FACING PAGE—When making a purchasing decision, think about the types of images you want to create, then buy what you need to accomplish that goal.

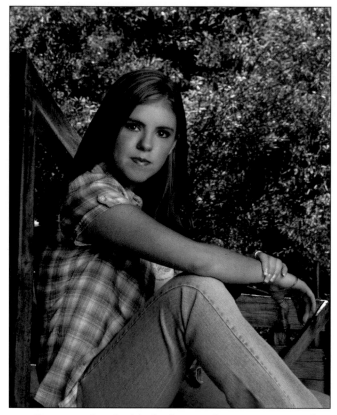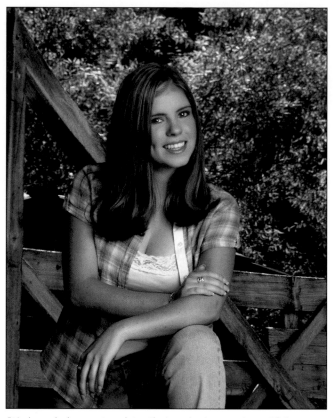

It's knowledge, not gadets, that make images beautiful.

Once you've decided what equipment you need to do what you want to do, you can go on to consider how much you want to spend and how durable the equipment is. When you look at equipment purchasing, remember that you will only *make* so much money this year in your business; how much you *spend* will determine how much is left over to live on.

Finally, you don't need seventeen backup pieces of equipment. You need a camera and one backup camera for each camera area (or photographer) you have. You need one backup light for every camera area—and that's it! If you do weddings, you may need an additional backup—but you still don't need six or seven camera bodies "just in case." If you have more equipment than you truly need, sell it and invest in learning how to use the equipment that's left!

▷ Learn to Use What You Have (Instead of Buying New Stuff)

I am not trying to put equipment manufacturers out of business here. I am just trying to get you over the

thinking that equipment in some way makes you a better photographer—because it doesn't. It's *knowledge*, not equipment or gadgetry that will make your images beautiful. The point here is simple: shoot with what you have and get better at using it.

Buy new equipment when your old equipment no longer works properly (or your repair bills are too high) and only buy what you need. If you shoot beautiful portraits with an old 35mm camera and your clients don't order sizes larger than 11 x 14 inches, you're all set! If you find that your clients want larger sizes than you can produce with your current equipment, then you have a reason to upgrade your equipment and a way to *pay* for the upgrades.

Many photographers struggle financially—and often it's not from a lack of opportunity to make money but because they squander money on things they really don't need in the first place. (No wonder I don't have equipment sponsors when I speak!)

2. Study Your Current Images

Developing a salable photographic style means that you have to determine what your clients are looking for. This goes beyond backgrounds and poses. You have to understand all of the qualities that characterize fine portraiture—the things that paying clients are looking for in your work. Let me say that again:

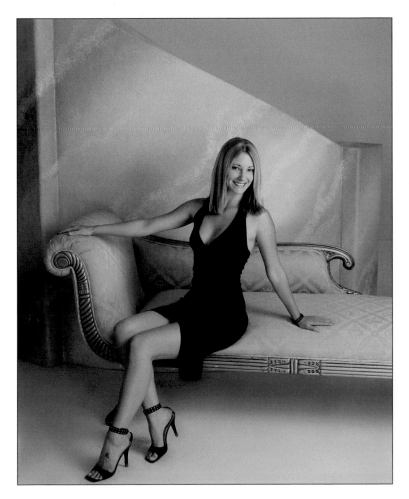

you have to understand what paying clients are looking for!

Many photographers (especially those new to the field) gain experience or try out new techniques by inviting people in for test sessions. The person doing the test session receives free photographs in exchange for their time and trouble. However, when a person gets free pictures from a test session, *of course* they are going to say that you are the most gifted, talented photographer on the planet. They will tell you that you are far more talented than the other photographers they have gone to. You should open a studio and clients will flock to your door! But wake up—it's time for a dose of reality! When a paying client praises you, it is validation for a

Creating salable portraits means really understanding what your clients are looking for and giving to them.

job well done; when someone gets something for free, their praise is a form of payment.

▷ What Does the Viewer of a Portrait Look For?

Unless you plan on giving your work away to paying clients, you have to know what paying clients are looking for in a photograph—and then you have to be able to create it in the camera. Let's start first with a question: what does the viewer of a portrait look at first?

Eyes. In photography class, we are all taught that the first thing people look at in portraits is the subject's eyes. The eyes are the windows to the soul—but if they aren't lit and posed properly, the windows are closed. Somehow, many photographers forget this

When the main light is placed too high, it provides more contour to the face, but the catchlights begin to disappear at the eyelid.

The problem only gets worse as the expression goes from serious to smiling. Not only are the catchlights not completely visible, but the one catchlight is noticably smaller than the other—giving the appearance of the eyes being different sizes. The higher mainlight also exaggerated the circles and smile lines.

With the main light at the correct height, the catchlights are bright and appear the same size. The facial lines are much less noticable.

I prefer to add an additional light underneath the subject to brighten the eyes, soften the visible lines on the face, and add a more glamorous look to the image.

Knowing that the eyes are the most important element in a portrait, I consider the eyes first when lighting a portrait.

important concept, lighting their images to create contour-defining shadows on the *face* without considering the *eyes*. Other photographers get so set in their ways that they actually forget to lower or raise the main light to ensure the eyes are lit properly in each pose.

Every light that illuminates a person's face produces reflections in the eye. In fact, you can see exactly how any portrait is lit just by studying the eyes. The light reflections (catchlights) in the eye give life to the

face. Knowing that the eyes are the most important element in a portrait, I consider the eyes first when lighting a portrait. Some photographers prefer to light the face first—and this is fine, provided you check the eyes and make sure they are properly lit.

How do you know when the eyes are properly lit? Well, about every ten years or so, it seems like a group of photographers (often they are judges for print competitions) get together and decide what the "correct" placement of catchlights in the eye should be—hence,

The current view on eye catchlights is that there should be one catchlight in the upper left or right quarter of the eye, with a slight crescent shaped catchlight in the lower quarter of the eye on the opposite side.

they pay me in cash. These real-world judges aren't flawless (unlike the models often seen in the images that are entered in print competitions) so you have to work hard and know what you are doing to make them look good. The rewards, however, can be much more meaningful than a ribbon.

Now, I've just had some fun at the expense of print judging, but many people do find that participating in print contests helps them grow in the direction they want to grow. If that's the case with you, then competing is a great idea. The point I'm trying to make is that you have to keep yourself grounded in reality and focused on what pays the bills. Do the prints that you enter for competition sell well? Does the style of photography that sells well for you also score well in competition? If so, by entering competitions, you are improving your photographic style—a style you know is salable in your marketplace.

If you find, however, that the images that sell well don't score well, any time you spend shooting images for competition is time spent trying to develop a style that doesn't sell. Unless your bank takes blue ribbons for your next mortgage payment, you might want to find another way to develop the marketability of your work.

setting the standard for how the eye should be lit. For years, the eye was to have only one catchlight in the upper right or left quarter. The current view on eye catchlights is that there should be one catchlight in the upper left or right quarter of the eye, with a slight crescent shaped catchlight in the lower quarter of the eye on the opposite side. If a print is to score well in a print competition, it should have the current "correct" catchlight.

This is the world according to print judges, though. I live in a world that has a different type of judge: clients. My judges don't hand out ribbons,

Going back to the eyes—the eyes should always have the most *predominant* catchlight in the upper right or left quarter of the eye. These catchlights should be the same size in each eye (when one catchlight is smaller than the other, it creates the illusion that one eye is actually smaller than the other). Pay attention to how the catchlights change with the pose, since this often diminishes the appearance of the predominant catchlight in one eye more than in the other. You must study the eyes of your subject and adjust your main light until the catchlights are in the proper position and appear to be the same size.

When I start training a young photographer, I find that the easiest way to have them light the eyes properly is to have them position the light and raise it to a height that shows no catchlights in the subject's eyes. At this point, they slowly start to lower the light until they see the catchlight in the correct position, with the intensity that is needed. Often long, thick eyelashes act like the brim of a baseball cap. Instead of creating a shadow on the forehead, however, they lessen the intensity of the catchlights in the eyes. As you would with a hat, lower the light enough to get light under the obstruction.

This is how you place the main light—and when you do, you'll see that the eyes have started to come alive. But don't stop there! At this point the eyes only have illumination from one point: the main light. With just this light, the eye color will only be visible with light-blue eyes; any other eye color will be lost. I want to see the color in every subject's eyes, so I bring in a second source of light from below the subject to light the lower part of the eye. This can be a reflector, piece of foamcore board, or a softbox. The intensity of this light should be less than the main light, because the main light should produce the predominant catchlight.

Pay attention to how the catchlights change with the pose, since this often diminishes the appearance of the predominant catchlight in one eye more than in the other. You'll need to change the main light position as the subject moves from standing posed to seated or reclining ones.

The ratio between these two lights varies depending on the how reflective the subject's eyes are. Most of the time the lower light/reflector is metered at 1½ stops less than the main light. If the main light is f16, for example, the lower accent light would read f8.5. This can change to a 1-stop difference if the subject's eyes don't reflect light well. This would mean the main light might read f16 and the lower accent light would read f11.

Just look into the subject's eyes—they are always the true indicator of good lighting. When you see one predominant catchlight in the correct main-light position and secondary catchlights in the lower eye (with visible eye color showing in at least half the eye surface), you will know that you have created a salable portrait.

Shadows. Once you have lit the eyes properly, what is the next characteristic that paying clients are looking for? The answer is shadows. We are all taught that light is our photographic paintbrush, but that isn't quite true. Painters and photographers have always struggled to give their canvas a third dimension—a sense of depth. When the illusion of a third dimension is achieved, the artist has taken a flat surface and given it life. If you study fine paintings or photographs, though, you will notice the illusion of depth is not produced by the *lightest* areas of the portrait but by the *darkest*. It is darkness that draws our

The subject's eyes are always a true indicator of good lighting.

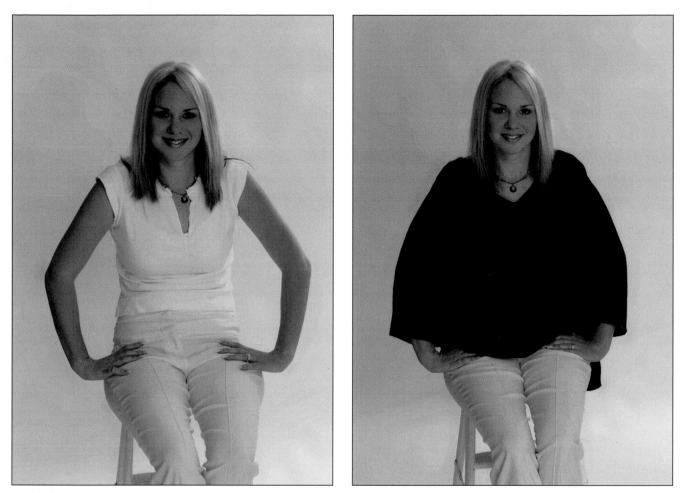

In the first photo, the young woman's tan skin is the area of greatest contrast, since everything else in the image is much lighter. In the second image, the black shirt draws attention away from her face—a bad idea.

eye to the light. It is darkness that give a lifeless canvas the illusion of depth.

For those of you who haven't studied art, let's take a real-world example. We've all seen photographs taken by the mall photographers or national photo companies. What is the one element missing from most of their portraits? They tend to look flat—lacking a third dimension—because (usually) there is no apparent shadowing. Controlling shadows is difficult for the inexperienced photographers who tend to staff these studios, so most companies reduce the lighting ratio to provide little or no shadowing. If light were our paintbrush, these portraits would be award winning, because they have nothing but light in them, right?

Contrast. Another common misconception is that our eyes are drawn to the lightest area of a portrait first. In fact, our eyes are drawn to *contrast*, not *light*. To illustrate this point, look at the two images above taken against a pure-white background. In the first photograph, everything (including the young lady's hair) is white or near white; her tan skin then becomes the darkest area in the portrait, and that's where your eye is drawn to first. In the second photo, the same subject has a black shirt on. In this sea of white, the black shirt becomes the darkest area in the photograph—and that's where your eye is drawn.

Now, knowing that our eyes are drawn to contrast, where should the area of highest contrast be? Where do you want the viewer of an image to look

Soft, light edges draw your eye into the frame and toward the subject's face.

first? The answer is *the face*—containing those beautifully lit eyes we discussed earlier in this chapter. Whether the portrait is head-and-shoulders, three-quarter-length, or full-length, the face should be the focal point. Because the eye is drawn to contrast, this means that the face should be either the lightest or the darkest area in the photograph. This is why so many photographers use a vignette to darken the outer edges of the photograph and draw the viewer's eyes to the lighest areas of the image (which would be the face in all but high-key photographs). This is so important that it bears repeating: no matter what your portrait style is, *your first goal is to direct the viewer's attention to the subject's face.* Everything in a portrait should be selected to help achieve that end—and this includes the lighting and shadowing, the clothing, the posing, and the background.

Understanding these principles can also help you to emphasize assets and conceal problems. For example, consider boudoir photography. In traditional portraiture, you draw the viewer's eye to the face; in boudoir photography, you use contrast, lighting, and your other tools to direct the viewer's attention to a part of the body that his or her romantic partner thinks is attractive. If the client has beautiful legs, a large bustline, or a washboard stomach, that is the focal point. This is what gives the portraits

their sensual appearance. If, on the other hand, your portrait subject has figure problems you know he or she won't want to see in the final portraits, you can use the same tools to conceal them—reducing the contrast on the area, posing the client to conceal the area, etc.

By paying attention to this, you can begin to create portraits that direct the viewers' attention where you want it and keep them from noticing what you *don't* want them to see. This gives you total control over your images, and it's the essence of photographic style: understanding what you are creating and using it to control the viewer's response.

Retouching and Printing. Believe it or not, retouching and the way an image is printed are an important part of your photographic style. Clients expect images to be free from blemishes, with the obvious lines and under-eye circles reduced to make the subject more attractive. Clients also expect the skin tone to resemble the actual skin tone of the subject (slight darkening for fairer-skinned subjects and slight lightening for darker-skinned subjects is usually acceptable, however). If you let unretouched images out of your studio—and I say this from both an artistic and a business standpoint—you're making a big mistake. Neither you nor the client will be completely satisfied with unretouched photos. Additionally, these subpar images will go out into your community as representative of your work—and you don't want potential clients to see them and think, "Oh, so that's the best they can do." This isn't a reaction that's going to make them run to the phone to book a session.

Everybody needs at least a little retouching to make them look their best—so clients shouldn't be allowed to skip this important step.

Therefore, clients shouldn't have the choice to skip retouching. Either increase the price of your portraits to cover retouching or make retouching a separate fee the client must pay for each pose they order (they pay the fee only once per image, regardless of how many prints of that image they order). To avoid having unretouched images leave our studio, we added what we call an "image fee" to most of our packages. We explain to clients that it is a charge for the color testing and retouching of the first portrait ordered from any pose. If you decide to charge an image fee, be sure note the amount (and give a brief explanation) in all your information; you don't want clients to be surprised when they order. Even if the client knows of this charge, they will on occasion ask why they must pay it. We explain that this is the only fair way to charge for this fee—after all, we have clients that order an entire package from one pose, while other clients will order from ten different poses. If we included the charge in the print price, we would be overcharging the clients who ordered from a single pose. We also have inclusive plans that have this fee built into the cost.

When it comes to printing, some photographers prefer a natural skin tone, with no additional colors or saturation added; other photographers like a rich, colorful skin tone. There is no right or wrong, just personal preference—but you had better make sure that your clients have the same taste as your own. With film, labs developed their unique style of printing skin

BELOW AND FACING PAGE—To avoid having unretouched images leave our studio, we add what we call an "image fee" to most of our packages.

tones and were very consistent in achieving the same quality of skin tone from client to client. Digital photographers, however, have taken control of this aspect of their work, as well. Whether you print in your studio or continue to work with a lab, how you adjust your files and deal with color management issues will greatly affect the skin tones in your final prints.

▷ Taking Control

To summarize, these are the common characteristics that paying clients look for in the images they intend to purchase. They want portraits that draw the eyes of the viewer to the face, and they want to see bright, sparkling eyes. They also want to see enough shadowing to give the image an appearance of depth. The portrait should be consistently retouched and printed to a determined style. These are the first steps in refining or defining your photographic style. This is the beginning of taking control of the images you produce rather than following the blueprint of another photographer without knowing why you are doing what you are doing.

This leads us to the next step in developing or refining your photographic style: consistency. The most important part of developing a style is that your style with be *visible in all your images*, whether they are created in the studio or outdoors. If your images don't have a common look, you haven't developed or refined your photographic style. This critical factor is the subject of chapter 4.

There are qualities that paying clients are looking for in every image—if you deliver them, you'll make the sale.

C onsistency is the heart of a photographic style. In the last chapter, we discussed some of the many characteristics that paying clients look for in fine portraiture. The next step is to develop a way to consistently produce those qualities in your work.

▷ Consistent vs. Boring

Before we start talking about consistency, I need to clear up a misconception. Many young photographers have a hard time seeing the line between *consistent* and *boring*. As you start out into photography, the one thing you don't want to become is one of those "old guy" photographers. You know the ones I am talking about—they've been shooting since the day after the camera was invented and they gave up on improving their photography years ago. Now they just want to keep cranking out photographs so they can make as much money as possible before they seize up

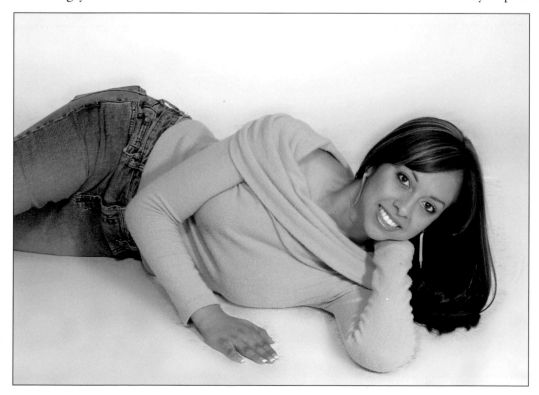

Being consistent means developing images that clients can recognize as yours. It doesn't mean being boring or never changing.

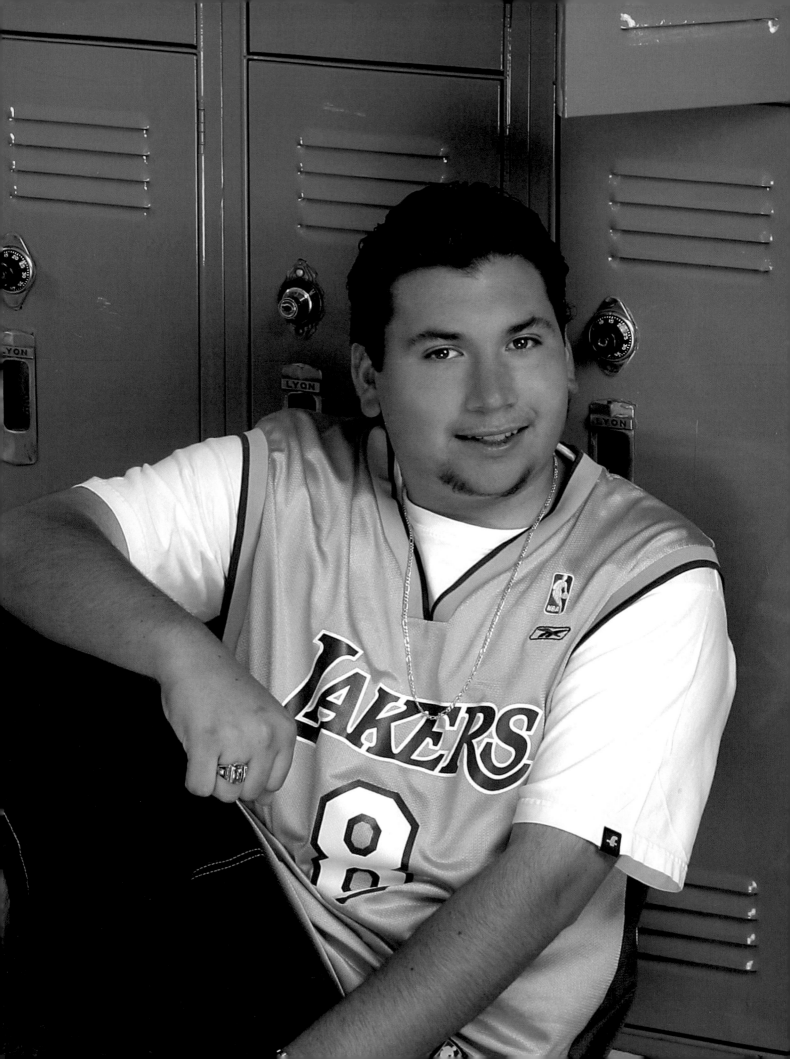

ABOVE AND FACING PAGE—Determine the characteristics that paying clients are looking for—then make sure that each portrait you create has them.

and meet their maker. No young photographer wants to be that "old guy." In fact, I don't think *any* photographer wants to become that "old guy!"

The Images Change, the Quality Stays the Same. Consistency in your photographic style doesn't mean you quit learning and evolving. I have been photographing for twenty years and my work changes each year. We try new ideas and concepts; we weed out the old ideas whose day has come and gone. You determine how you want to achieve the characteristics in your work that paying clients are looking for—then make sure that each portrait you create has those specific characteristics.

Think of it in terms of a restaurant. Imagine that you are the chef in a fine restaurant. You bring your patrons the finest food available. Naturally, you try out new recipes to keep your menu up to date and give people something new to sample. The dishes you serve day in and day out, however, will be crafted in such a way that they taste the same whether a patron orders them today or a month from now. Imagine a diner comes in on a business trip and orders your delicious venison in a cherry cream reduction. He loves it and can't wait until his schedule brings him back to town to enjoy it again! When he returns, you can bet he'll be disappointed if it doesn't taste like he remembers it.

That kind of consistency is what diners expect from a premier chef. It is also what your clients expect from a premier photographer.

ABOVE—Original image.

TOP RIGHT—As you open the image file, you look for the obvious flaws and blemishes. This young lady has nice skin, but the summer weather in California's Central Valley has made it shiny. Additionally, her tanning has left distinct strap marks.

CENTER RIGHT—The first step is to select the area from which you will clone the good skin and choose the right brush size. We usually start between the eyebrows to find smooth skin. When we are working with retouching, the opacity is set low (around 25 percent) and a soft-edged brush is used.

BOTTOM RIGHT—The first thing we do is smooth the skin by eliminating the shine, removing blemishies, and blending blotchy areas.

TOP—Once the basic retouching is done, we soften the circles under the eyes and the suntan lines.

BOTTOM—The final step is to enhance the eyes. We brighten the catchlights and add impact to them. If the catchlights do not appear the same size, we correct the problem and ensure that they match.

ABOVE—Final image.

▷ Understand Your Clients' Tastes

The Eyes: Classic or Contemporary? Let's talk about the eyes. As we have already discussed, these are the most important part of an image. That said, how do your clients want their eyes to appear in your work? Do they like a more contemporary look with catchlights visible in the lower part of the eye, or do they like the classic look of a single catchlight in the eye?

Shadows: Dramatic or Subtle? What about shadowing? Do your clients want dark, heavy shadowing for a very dramatic look, or do the enjoy a more subtle use of shadow—just enough to bring out the depth in your images?

Retouching: Glamorous or Natural? What about your retouching? Do your clients want a glamorous look that eliminates all imperfections, enhances the eyes, and highlights the lips? Or do they prefer a more subtle retouching style that only removes acne and subtly softens everything else? On the facing page and above you can see one strategy for basic retouching on a portrait. You'll need to develop your own style that matches your clients' tastes.

▷ Allow for Variety, Plan for Problems

Although consistency is important, it does not supercede the need to make every client look his or her best. For example, even if your clients usually like heavy shadowing, if you are photographing a young lady with a large nose, that will not be the most attractive look for her. In this case, you'll want to turn her face toward the main light to reduce the shadow on the side of the nose. This will make the nose look smaller. Alternately, your style of retouching might be more glamorous, but if you are retouching an elderly lady and remove all the wrinkles from her face, it will look completely unnatural.

On a related note, the reason I am always able to create a salable portrait is that, no matter what, I plan on having problems and I'm ready to adapt. I am shocked when I everything works just as I planned. I know that something will usually happen to make every shoot more difficult, so I am not surprised when challenges arise. By looking at things in this way I can keep a cool head and figure out how to get my job done. Most people focus so much on a problem, they can't come up with a solution.

▷ Consistent Digital Imaging

Training Your Staff. However you decide the client will pay for retouching (see page 33), be aware that the retouching of your images affects the final look or style. With film, it was up to our labs to ensure that their retoucher produced a consistent look. Digital photographers, however, are now doing their own retouching in-house, so the burden rests more and more on us. Since it is fairly simple in Photoshop to retouch the average image, most photographers are having their staff do the retouching during slow times. The problem is that each person tends to develop a method of retouching that varies from employee to employee. As you look at your images, this can result in a visual difference.

Original image.

As a creator photographer, it is your job to develop a style of retouching that produces the look you want. Once you develop this process, you must teach it to each person who retouches images and then make sure they follow all the steps you have taught them. Keep in mind that there are many ways to do the same job in Photoshop. When you develop the style of retouching you expect from your employees, don't just show them what you want retouched, but specify the tools you want them to use to achieve the retouching. Each tool produces a slightly different look, and in order to control the look of the image, you must be in control of the process. In the following photos you will see the process of retouching we use and teach to our computer staff. Each step is explained, and the final images show the overall look we are going for.

Color-corrected image.

Final retouched image.

Using Actions. Beyond retouching, many photographers add vignettes, diffusion, sharpening, and other effects to their images to enhance the overall look. If you add these enhancements, it's best to set up the process of the enhancement as an action.

Enhancements are a part of the images you provide to your clients and need to be consistent. Using actions in Photoshop to complete as many enhancements as possible can ensure the results you want—and help you save time. You can create your own custom actions to quickly apply any effects that you use on a regular basis. Consult any Photoshop book, or the Photoshop help files, for step-by-step techniques for creating actions.

There are also many actions available for purchase. Recently, I was at a senior convention and saw a lecture by Kirk Vulcan. He had produced a CD of actions that he offered for sale. One action that was really interesting was called The Move. This action softens and darkens the area around the subject to draw the eye to the subject. It's broken down into four layers: the first is the original image; the second is a softening layer that can be erased from the parts of the subject you want to remain in critical focus; the third layer uses a screen-transfer mode to lightly increase contrast on all parts of the photograph; the fourth layer darkens the background of the photograph. If you are good with Photoshop, you could probably create a similar action; for me, it was well worth the $100 for all the actions on his CD.

▷ Consistent Standards in Consultations

You must also develop consistency in the way you handle your clients. This begins by taking the time to

completely prepare your clients for their session. Again, one of the major differences between the copier and the creator is that the creator photographer has taken control of everything that appears in the frame—and this includes the subject. If you don't adequately prepare the client for the session and she selects the wrong clothing, puts her makeup on like a clown, and has bed-head, that's *your* fault, not the client's.

There are occasions when a client doesn't listen to what you have told them in regard to clothing, hair, and makeup, but this is the exception, not the rule. Ninety-five percent of the time when a client doesn't prepare properly, it is because of the photographer's lack of communication about the importance of proper preparation for the success of the portraits, or his inability to communicate the importance effectively.

If you doubt this, try talking to the average photographer about something other than photography.

You get off the subject of lights, cameras, the studio, and complaints about clients, and many photographers don't have much to say. If you can't communicate well with friends and family without talking shop, then you can't communicate with your clients either. When you are done with this book, go to the library or book store and look for books on communication. I think everyone has the words to communicate inside them, some people just have a little trouble getting them out or tend to choose words and phrases that don't convey their message clearly to the listener. If you find communication is hard for you, reading these books and learning how to communicate effectively will improve your photography more than any book on lighting and posing ever will.

To prepare our clients, we used to set up a time for a consultation. We would select their clothing, explain makeup and hair, as well as get ideas for the type of photograph they envisioned and wanted done. As the

Learning how to communicate with your clients is more important than any lighting or posing technique.

We now use a slide and video show on CD to prepare our clients for their sessions.

volume of our studio increased, doing a one-on-one consultation with every client eventually became impossible. Instead, we put all the information onto a video, combining photographs and video segments to illustrate each point. To reduce production costs, we now put the consultation on a CD. We use a slide-show program called 3D Album—an easy-to-use program that produces some beautiful special effects and allows us to do voice-overs, explaining the various points the images illustrate.

Over the years, many photographers have asked about our consultation video and, since they got the idea from one of my books, sent me a copy of what they produced. Some of these videos were excellent and some were a little rough. Here are my suggestions. First of all, show *images*, not you as the photographer talking to the camera. Use voice-overs, so stuttering and stumbles can be edited out. Second, don't

do the voice-overs yourself unless you have a distinctive voice. By distinctive, I don't mean unusual—a voice like a radio DJ or news anchor is what you are looking for.

The video or CD is a good tool, especially if you have a high-volume business or you find that you don't always communicate with your clients as effectively as you might like. At the very least, a video or CD will ensure that the client knows how to prepare for their session and understands that if they don't prepare for their session properly, they will have to pay to retake the images or pay to fix the problems digitally. This CD saves us so many client-related headaches every year. How many times as a business owner do you hear, "I wasn't told ____!" With the CD, clients are told and retold. If they don't listen to your suggestions, you are not responsible.

4. Momentary Excitement ≠ Lasting Appeal

Before we go any further, I want to emphasize, once again, how important it is to take control of the images you create. This is the only way to achieve real success in photography. Many photographers who have problems with their business never realize it's because they haven't taken complete control over what they create. All the creative marketing in the world won't help if you can't consistently produce images that your clients want to buy. But even that isn't quite enough—not only must you produce images that clients will want to take home with them, you need to ensure that these portraits are of such a quality that people will still be enjoying them for years to come. That's real customer satisfaction—and that is what builds repeat business and great referrals.

▷ Conscious Choices About Every Element

It's a sad fact that, while wines and cheese often become better with age, many portraits don't. This typically happens when the elements in a photograph don't come together to visually "make sense." For a photograph to visually make sense and have a sense of style that ages well, each aspect of the portrait must coordinate to all the others. This is achieved when the clothing a client is wearing is coordinated to the pose, scene/background, and lighting, as well as the predominant lines and textures of the portrait. All of

When the elements in a portrait work together and make sense, the portrait will have lasting appeal.

these things are selected to achieve the overall look that is appropriate for the intended use of the image.

Here's a common scenario. A client comes to a photographer to have a family portrait taken. After the session, she sees the proofs, gets excited, and places her order. The order comes in, the client picks it up, and she hangs the wall portrait proudly in her living room. A month goes by and she changes where the portrait is hanging, because it just doesn't look right. She tries many locations around the house and it still doesn't look quite as it should. At this time, she begins to realize that her prize portrait isn't such a prize after all. She starts to notice flaws. The background or scene that she hardly noticed before suddenly doesn't seem to go with the people in the portrait. One subject's tie is really crooked, and another has bed-head. Soon, the client begins wondering why she made such a stupid mistake. Will she be back for more portraits or even extra prints for her family? Will she refer her friends? Doubtful.

Photographers do the same thing, of course. They see the proofs from a test session and they get excited. They order a sample for their studio. When it comes back from the lab, they aren't as excited. They start to notice things they didn't notice when they first saw the image.

This is a good lesson on the difference between momentary excitement and lasting appeal. It's easy to create momentary excitement. Even snapshots can do that! It's a different ball game altogether to create a work of art that stands the test of time. Doing so means, again, making conscious decisions about everything in the frame. Think of the great portrait painters of the 19th century. These artists didn't just "happen" to create masterpieces, they carefully crafted every element of each image. They planned every aspect of the portrait to ensure it was just right. Even though the clothing and hairstyles are no longer in fashion, everything in these images works together so

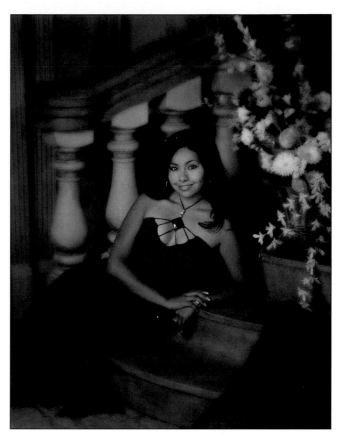

Many of us get so wrapped up in looking at the lighting, posing, and background that we never think of the feelings that our images are going to capture.

flawlessly that they are still a pleasure to view hundreds of years later. There's no reason not to strive for the same quality in your portraits!

▷ The Impact of Emotions on Portraiture

We sell an emotional product, but many photographers take an approach that is strictly technical. Many of us get so wrapped up in looking at the lighting, posing, and background that we never think of the *feelings* that our images are going to capture. As you read through the following chapters, consider how the decisions you make come together to create the overall feeling of the image. As noted above, keep in mind that the decisions you make about each element must not be made individually but carefully coordinated with each other to produce an image that make sense visually.

5. Clothing Choices

I have started our discussion of photographic choices with clothing for several reasons: first, because the clothing sets the look and style for the entire portrait; second, because it's a simple reality that people buy portraits they look good in and clothing is a big part of that; and finally, because it's the one variable that you don't have complete control over. You can have a consultation with a client, you can explain all the problems with various colors, patterns, and styles of clothing, but when all is said and done, some clients won't listen. They have their favorite outfit selected and that's what they are going to wear! While you have a multitude of options for every other aspect of the image, you will always be limited by the clothing your client brings in.

Most photographers have gotten to a point where they coordinate the basic color of a client's clothing to that of the background, set, or outdoor scene. Darker tones of clothing are paired with darker backgrounds; lighter tones of clothing are paired with a lighter background. This makes the viewer's eye focus on the person and not what the person is wearing. It also gives you the ability to hide body size, because you don't create an exact outline of the client's body as you would with a white dress on a black background. To create a portrait that has a sense of style, however, you not only need to coordinate the color of the clothing to the scene, but also the style of the clothing, which must reflect a similar feeling as that shown in the scene.

In the outdoor portrait on the facing page, the feeling produced by the scene is elegant. The first outfit the young lady wanted to wear didn't coordinate with the overall scene. We suggested she change into the more elegant clothing, and a portrait that had a definite sense of style was achieved. The young lady's flowing hair, her trendy red blouse, and a perfect pose all came together to produce a striking portrait. While the clothing and hairstyles may change and the person in the portrait may age, the appeal of the portrait will remain.

▷ Don't Limit Your Choices

Probably the best advice I can give you in regard to your clients' clothing is to have them bring in *every-*

The young lady's flowing hair, trendy red blouse, and perfect pose came together to produce a striking portrait.

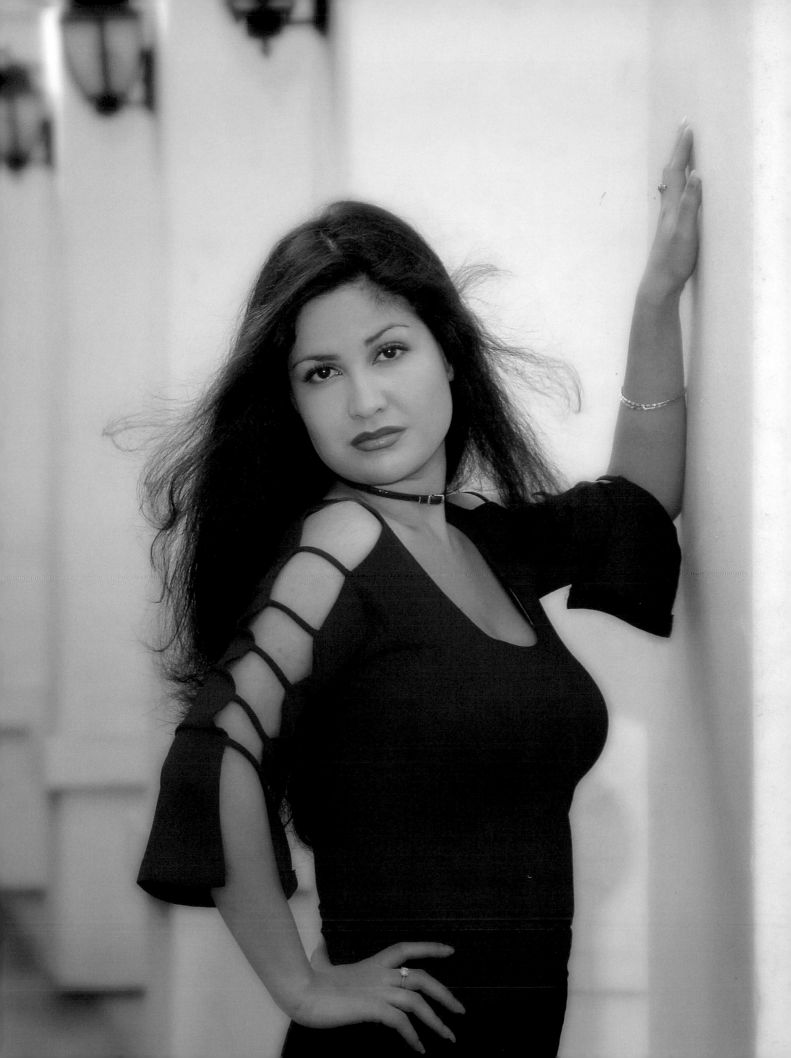

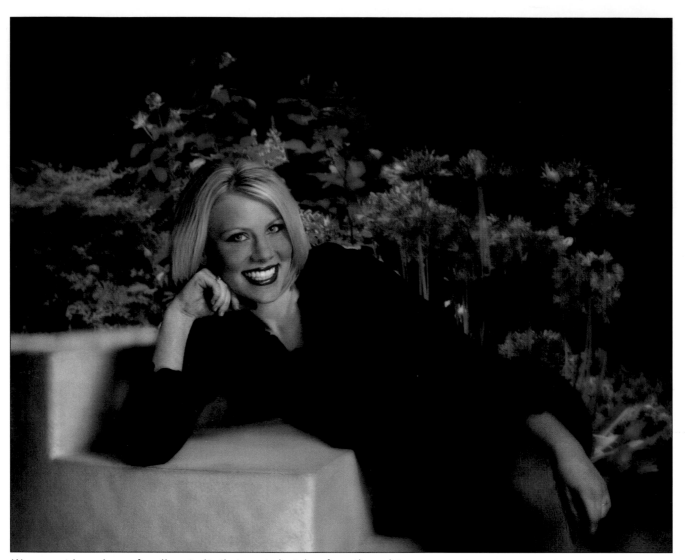

We suggest long sleeves for all portraits that are to be taken from the waist up.

thing for you to look at. I am not kidding. At our studio, the average girl brings in ten to twenty-five changes, and the average guy brings five to ten. Again, this is all part of making a successful, salable portrait.

We also tell our subjects not to bring *only* formal clothes or *only* casual clothes. We want to see three distinct styles of clothing: casual, trendy, and elegant. Jeans, shorts, summer dresses, and t-shirts fall into the "casual" category. Leather and jean jackets, fashionable blouses and shirts, as well as dresses that the average young lady would wear out "clubbing" would be considered "trendy." Suits, tuxedos, and gowns would be considered "elegant."

Women tend to be very good about bringing in what you've asked them to bring. With guys, on the other hand, you have to be very explicit. That way they can write it all down and give it to their mom, girlfriend, or wife so she'll know what to buy. For our purposes, we have gentlemen bring in at least one suit; a trendy jacket (leather, denim, or a letter jacket); and a variety of casual shirts, jeans, and pants. We remind guys at least three times to bring a pair of socks that will match the color of their pants. Young men tend to wear white socks with everything—even a black suit and black loafers. We also remind them they could be asked to go barefoot, so they should make sure their

nails are trimmed and presentable. If you get your male subjects to follow these simple instructions, you are lucky! More often, you'll still have to do at least a little improvisation! The following are a few additional suggestions:

Long Sleeves. In our consultation CD, we explain how important it is to bring in the proper styles of clothing. We suggest long sleeves for all portraits that are to be taken from the waist up. Large arms are much less noticeable in a full-length pose, so short sleeves are less of a problem in these portraits.

White and Black. For studio portraits, we ask that subject bring in one item that is white and one item that is black. These two colors will eliminate any problems with color harmony in a selected background. White will coordinate with any lighter background; black will coordinate with any darker one.

Outdoor Portraits. For outdoor portraits, we suggest that the clients avoid both black and white clothing. Instead, only mid- to dark-toned clothing (burgundy, green, blue, khaki, etc.) is recommended. This coordinates best with the colors in an outdoor setting, allowing us to create portraits with a more unified feel.

Dark Clothing. We suggest that anyone who worries about weight should bring in a variety of darker colors of clothing and several choices that are black. Black clothing is amazing. It will take ten to thirty pounds off of anyone who wears it, provided you use common sense and pair it with a black or very dark background. If you are photographing a family and Dad has a "beer belly," ask him to wear a black sweater. Unless his stomach is huge, it will appear flat in the final portrait. If Mom has larger hips, put her in a black skirt or dress and she will appear noticeably thinner.

Coordinated Outfits. We ask subjects to bring a matching pair of pants or skirt for each top they bring

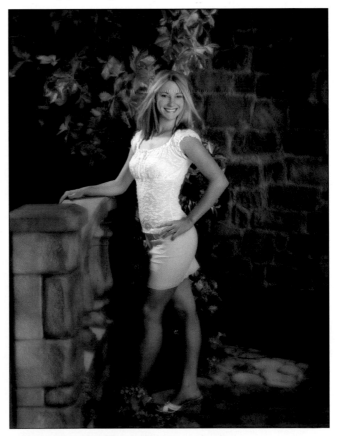

We ask our subjects to bring one black and one white item. These colors work well with any background color.

FACING PAGE—We tell our female subjects to wear the tallest heels they have for each outfit. Heels change the shape of the legs, making them look longer.

ABOVE—Sometimes jewelry enhances an image, other times it can be a distraction. As a creator, the choice is up to you.

in. Since we have gone digital, we take two variations for each pose/background idea: one full-length and one closeup. Even if the portrait will only show them from the waistline up, we want the pants/skirt to match.

Shoes. The other important suggestions we make are about shoes. Guys have it easy—they have few choices. Women, however, have many choices. We tell them to wear the tallest heels they have for each outfit. If a woman only has flats or heels less than two inches tall, we either have her go barefoot or don't show her feet. High heels change the shape of the legs in a very flattering way, making them look longer and more toned.

Be on the lookout for shoes that are too small. Many women are convinced they wear a size six, when they actually wear a nine. If their toes hang over the ends of their open-toed shoes, this could be an eyesore in the portrait. If this is the case, don't show the feet.

Panty Hose. If a woman's legs are showing, panty hose should be worn unless she has very tan legs with great muscle tone. The nylons will not only make the legs look better by darkening them but will make them appear firmer and disguise signs of cellulite or bruises. Panty hose should never, however, be worn with open-toed shoes.

Jewelry. If the client is wearing a ring, bracelet, or necklace, you need to determine whether it needs to show in the image. If the jewelry is related to the purpose of the portrait (like a ring in an engagement portrait), look for the best way to incorporate it into the image. If the jewelry doesn't hold special meaning, you may decide to ask the client to remove it, or you might hide it in order to avoid creating distracting glints of metal in the image. Remember, a creator is in control of the smallest detail of the image. As I said before, everything in the image (down to the smallest detail) is there because the creator photographer wants it there.

▷ **Common Problems**

With clothing, the easiest way to know what to do is to know what *not* to do. If you think in terms of all the problems that clothing can create for your clients and then help them avoid these problems, you will learn how to use your clients' clothing to make them look their best. Here are some common problems that should be avoided.

Too-Tight or Too-Loose Clothing. We warn clients against wearing jeans or pants that are too tight around the waist. Unless the subject is in great shape, he or she will have a roll where the tight jeans cut into

Many clients forget to bring the correct undergarments to coordinate with the outfits they have selected for the shoot. For women, for example, strapless dresses require strapless bras. Guys often forget to bring dark socks to wear with dark pants.

the waist. Tight clothing also affects the subject's ability to pose comfortably. I have had some seniors turn beet red because of tight pants as they try to get into a pose. For this reason, we ask all of our clients to bring in a comfortable pair of shorts in summer or sweatpants in winter, to make it as easy as possible to get into the poses—at least those that won't show below the waist.

If women have a frequent problem with tight jeans, guys (especially young guys) have the baggies. This cool-looking (so they think) style has the crotch that hangs down to their knees, while at the same time revealing undergarments and butt-cleavage to the world. Just try to pose a client in a seated position when there are three yards of material stretched out between his legs. Try to have him put his hands in pants pockets that are hanging so low he can't even reach them.

In general, clothing that is loose-fitting on a person who is thin and/or athletic will add weight to the person in the portrait, especially if the garment is loose at the waist or hips. Tight clothing will add weight to those who are heavier. With tight clothing on a heavy person you can see tummy bulges, cellulite, lines from waistbands, and every other flaw that weight brings to the human body.

Wrong Undergarments. Many women also forget to bring in the proper undergarments. They bring light clothing, but only have a black bra and underwear. They bring in a top with no straps or spaghetti straps and they don't have a strapless bra. In this case, they either have to have the straps showing or not wear a bra, which for most women isn't a good idea.

Guys are no better. I can't count the number of times I have had a guy show up with a dark suit and nothing but white socks. Some men (okay, *most* men) tend to be more sloppy than women, which means that the clothing they bring often looks like it has been stored in a big ball at the bottom of their closet for the last three months. Many show up with clothing that used to fit ten years ago when it was actually in fashion.

▷ **Talking with Clients About Clothing Choices**
By setting the clothing guidelines discussed above, we ensure that there are several choices available when a favorite outfit is a bad choice for a particular subject. Still, clients sometimes feel very strongly about wearing clothes that you know don't make them look the way they'll want to in their portraits (remember, people buy portraits they look good in!). It can require some tact to raise these issues—but there's no point in proceeding with the shoot when you know the client isn't, ultimately, going to like the way he or she looks!

To avoid embarrassing your subject, the key is to stick to generalizations and never discuss the client's appearance directly. For example, all photographers learn that long sleeves can be used to avoid showing the upper arms. If you just tell a woman not to wear long sleeves, she is going to think, "I'll wear what I want to!" However, if you take the time to explain that many women worry about their upper arms looking large and that covering them with clothing will make them photograph better, they'll do it. Appearance is very important to women, so explain to each female client how she will look more beautiful if she follows your advice.

You can use this same approach when you are talking with a female client about the type of portrait she wants taken. Let's say you are photographing a woman who is sixty pounds overweight and wants to take a full-length portrait. However you pose and light her, it will be really difficult to produce a salable full-length photograph of a person who is that overweight. At this point, most photographers (especially male photographers) would just take the picture the way the client wanted it. Then, when the client complained about looking fat, the photographer would respond, "Well" So much for tact!

More direct photographers would just say, "You don't want to take a pose full-length—you're too heavy!" These are the photographers who spend a

Appearance is very important to women, so explain to each female client how she will look more beautiful if she follows your advice.

Many male photographers make mistakes in their choice of words and inadvertently end up offending their female clients.

thing like you!" Although this man loved the portrait and thought his wife looked beautiful, his choice of words created a few tense days around the house. Many male photographers are the same way. They don't mean to offend their clients, but their choice of words does just that and, unlike a wife or girlfriend, your clients *won't* forgive you.

The proper way to handle the overweight young lady who wants to take a full-length pose would be to say, "Most women worry about looking as thin as possible, and most worry about their hips and thighs appearing large. Usually, if a woman is concerned about her weight at all, it's best to take the photographs from the waist up. Now, is there anything you want to do full-length, or do you want everything from the waist up?"

If you refer to women in general and not to the client specifically, you spare her feelings and still inform her of the pitfalls of full-length portraits. (For you male photographers, don't try this technique at home. Instead, tell your wife she looks absolutely beautiful no matter what she has on. Oh—and leave off the word "today," when you tell her she looks beautiful—unless you want to imply that she didn't look beautiful yesterday!)

▷ The Story of the Angora Sweater

Sometimes clients just want what they want—regardless of your advice. I learned my lesson about how strange client expectations can be years ago when I

great deal of time on the couch at home and never realize what they said to make their wives mad. This reminds me of a story I heard from a mother of one of our seniors. She said she had gone to a glamour studio for portraits of herself. She thought she looked beautiful and bought her husband a large wall portrait of her favorite pose, which she gave him for his birthday. When he opened the portrait his jaw dropped. It took a minute before he could speak, and then he said, "This is absolutely beautiful, it doesn't look any-

started in senior photography. Like most photographers, for classic portraiture I would select a low-key background for darker colors of clothing. Then I would use background and accent lights to ensure separation of the subject. This worked well until I photographed my first senior whose mother went out and spent a fortune on an angora sweater. With a black sweater on a low-key background, you couldn't see the soft little hairs that would identify it as an angora sweater—and the mother threw a fit. She asked what kind of photographer I was that I didn't show the texture in the sweater!

After the lady vented for a while, I explained that the focus of the portrait was her daughter, not her daughter's sweater. I also explained that with fair-skinned subjects like her daughter, it is customary to print the portraits slightly darker to ensure a healthy skin tone. The mother said she didn't care about any of that, she wanted to see the little hairs of the angora. Since she had returned the sweater to the store after using it, we couldn't reshoot it. Therefore, she insisted I print the photograph light enough so that she could see it was an angora sweater. When she picked up her 16 x 20-inch print, her daughter looked like a ghost, but you could see it was an angora sweater, and she was happy as could be.

It just goes to show that art is determined by the eye of the buyer not the creator.

Many male photographers are at least a little style challenged. If this is you, don't be afraid to ask someone (maybe your wife or girlfriend) for help in coordinating the best possible looks for your clients.

▷ For the Fashion Impaired

To be absolutely honest, many male photographers are style challenged—especially when it comes to women's clothes. If this is you, don't be afraid to ask your wife, girlfriend, or a female employee for some help. The next time your wife asks you to go shopping with her, go! Look at the clothing that is in style. What are the hot colors? (As a photographer who wants to control every aspect of their photography, this is important research. After all, how can you coordinate clothing colors to background colors you don't even have?) If you're really not confident in your abilities to discuss fashion with female clients, work with a fashion-savvy woman to create a detailed list of the various styles and types of clothing your clients are to

bring in. Then, if you have to explain this to a client, you will have something to work from.

If you find that you are fashion impaired—if you think Berkenstocks go with dresses or cowboy boots go with a nice suit—you should hire an assistant who can help you better coordinate the sessions. This is one of the best investments you can make. Look for a person with great personal fashion sense. How can you tell? Look at how they dress for the interview—do they look fashionable, or like they just put on their one good suit (which doesn't quite match their shoes)?

Here's some advice for everyone—not just the fashion impaired: hire people to assist you who are strong in the areas where you are weak. For instance, I know some photographers who excel at the coordination of all the aspects of an image but are weak when it comes to the technical skills of photography itself. If this is your strong point, consider hiring a camera operator who is good at lighting, then spend

your time working with the clients. In either case, using other people's skills is the best way for you and your business to become more than what you are right now.

▷ Finishing Touches

To achieve a portrait that has a sense of style, you need to think about every detail in the composition. This means taking the few extra seconds to really look at the subject's outfit and make it look its best. Double check to make sure that the clothes aren't wrinkled, that the hem isn't falling out, and that there are no stray threads hanging out. Check that the subject doesn't have a bra strap peeking out, that ties are knotted correctly, and that collars aren't flipped up. If the subject's clothes have unflattering folds or wrinkles, pull them out for a more better look. If you don't already consider how these little details will affect the portrait you are creating, you should start immediately.

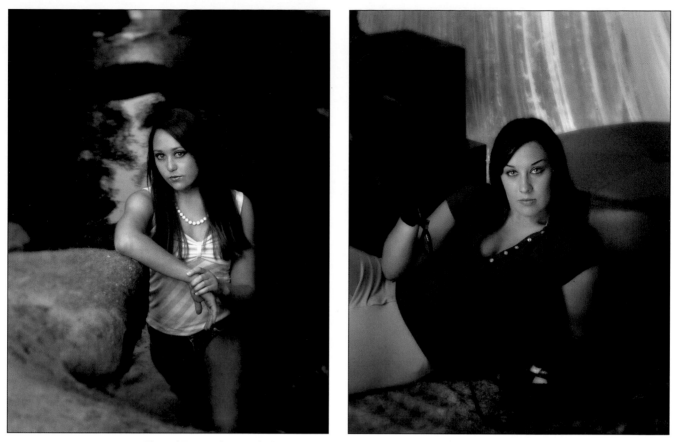

ABOVE AND FACING PAGE—The subject's choice of clothing will limit the kinds of portraits that will be appropriate—but you can also look at the clothing choice as a clue to the type of portrait that should be created.

▷ Take Your Clue from the Clothing

As noted at the start of this chapter, the subject's clothing will limit the kinds of portraits you can create. But you can also look at the subject's choice of clothing as a clue as to the type of image that should be created. When a young lady walks out of the dressing room in a pair of shorts, barefoot, and with a summery top on, it doesn't take a rocket scientist to figure out you'll be creating a casual image. When a girl comes out in a prom dress, again, it isn't difficult to select a glamourous background, lighting, and posing strategy to suit the dress.

Of course, you can also decide to use a style of posing that isn't the obvious choice—in fact, many of the trendy styles of clothing that are worn today virtually eliminate the normal limits when it comes to the unique backgrounds and unusual poses you want to try. Still—even when you're going for an unexpected look—you need to make sure that everything in the portrait comes together and makes sense visually.

The next step is to select (or modify) backgrounds or scenes to coordinate with the client's clothing—and this is the subject of the following chapter.

6. Background Choices

The style of clothing is what will determine the overall look of the photograph. The lighting, posing, and background will all have to coordinate to the clothing you and your client have decided they will wear. This is one of those, "Which came first, the chicken or the egg?" topics. In a perfect world, you would

explain to your client to bring in the three styles of clothing (elegant, trendy, and casual). They would come in with the proper clothing, and then you would select each element of the portrait to coordinate with those clothes. There are two problems with this thinking. The first is that all clients aren't always going to listen to what you have told them and, second, many clients are going to want backgrounds that they just don't have the clothing for. This means you will have to improvise and make some decisions about how to coordinate the background with the clothing.

> ▷ **Analyzing Backgrounds and Scenes**

Creating a salable portrait means selecting a background that makes sense with the clothing and produces the desired overall look for the portrait. Whether in the studio or at an outdoor location, the lines, textures, and colors of a background communicate to the viewer. Just as a bathing suit will produce a different style of portrait than an evening dress, one painted background will actually provide a complete-

ly different style of portrait than another. The same is true for outdoor scenes. You can't coordinate a scene to any other aspect of the portrait if you don't understand how to interpret the scene/background visually.

Basic Analysis. Let's start with some simple backgrounds, since these are easier to analyze. First, look at the two painted backgrounds at the top of the facing page. If you had to photograph a man in a business suit, which one would you pick? What about a senior in a denim jacket? This is an obvious choice, right? The business portrait would be done on the classic cloud background, and the senior on the blue crinkled background.

In the next set of examples, at the bottom of the facing page, which background would you select for a senior in a black and white prom dress? Which would you select for a senior in a gold sequined dress? Obviously, you would select the black satin background with the strong highlight for the black and white dress (see page 61 for an example), and the warmer background for the gold dress.

Which of these two choices would be best for a teenager in a denim jacket? How about for a man in a suit?

You have two subects: one in a gold evening gown, one in a black and white gown. Which background do you choose for each?

When you go outdoors, it becomes much easier to read the feeling a scene portrays. Coordinating the clothing and posing to the scene to achieve an overall sense of style becomes easier. A typical park or garden scene is a more casual setting, therefore more casual clothing and posing is required. An outdoor setting with columns and fountains is obviously more elegant and requires more elegant clothing. To achieve a sense of style and to visually make sense, you wouldn't put a woman in an elegant dress in the middle of what looks like a forest, nor would you put a girl in overalls in a scene that appears to be the outside of a castle.

These are choices that many in our profession never make. To the copier, these decisions were much too deep for the three-hour seminar on which they've based their style, so they just photograph each client on whatever background is up in the studio or at whatever location they happen to be. If the final portrait doesn't age well, if it has no sense of style, these photographers will find a way to make it their client's fault or blame it on a lack of equipment. (That's a common one, "If I just had the new battery and flash, then the photographs would have been better!") As we discussed in previous chapters, however, your style isn't found in a seminar or piece of equipment. Style rests in your knowledge of how to produce a consistent and salable portrait under any circumstances—a portrait that has the qualities paying clients are looking for.

Key Elements. How do you interpret a scene or background? You pay attention to the first thing that you, as the photographer, notice about the background or scene. Did you notice strong lines, heavy textures, or contrasting elements? What you noticed first is what the viewer of the final portrait will notice first and that is the key element in the scene.

Lines and Textures. The predominant lines and textures in a scene or background are what visually communicate its overall feeling, so be sure to evaluate

ABOVE—When you look at a scene or background, try to identify the predominant elements.

FACING PAGE—Clothing determines what style and color of background will be most appropriate for the portrait.

these carefully. Studying art theory will help you determine what feeling these lines and textures communicate. The lines of a scene can include the painted lines of a studio background or columns of a set. Outdoors, lines can be produced by trees, blades of grass, buildings, and even paths or walkways. Interpreting the predominant lines is fairly simple. Heavy, straight lines going vertically or horizontally through the frame produce a strong, structured environment. Dominant diagonal lines also produce a strong feeling but are less structured and rigid. Lines that are curved or bowed are softer, producing a feeling of romance or understated elegance. Because of the traditional associations, linear backgrounds are often considered more masculine, while ones with curved lines tend to be considered more feminine. For

Some types of backgrounds and sets work better with casual clothes, some work best with more dressed-up styles. In both of these images, curved lines help create a softer feel.

example, think of the columns commonly used as set elements by photographers. Rounded columns would be considered more feminine, while squared columns would be considered more masculine.

This does not, however, mean that you should only use "feminine" backgrounds when creating portraits of female subjects. Many of the traditional ideas about what's feminine and what's masculine just don't apply to today's clients and their tastes. Plus, there are factors beyond gender that must be considered when selecting a backdrop. For example, you will find that cloud backgrounds work better with more elegant types of clothing than backgrounds that have strong diagonal lines. Diagonal lines work well with casual clothing. As you begin looking for the feeling that the backgrounds convey, you will start to pick up on the ways the various lines and textures alter the feeling of the background.

Another element to consider when evaluating a background is texture. Texture is basically an arrangement of small lines—lines that can be interpreted according to the above criteria. For example, the leaves of a maple tree (with many curved and diagonal lines) create a softer texture than those of a pine tree (with mostly straight lines).

Let's look at an example of using an understanding of lines and textures to select a background for a location portrait. Your first client of the day shows up at an outdoor location. He is a fireman wanting to take a portrait for his wife. Without any prior discussion as to the purpose of the portrait, you'd have no direction to take the session. But let's say you have talked with the fireman about the portrait you are to create. He said that he has been working out for the last year, has abs of steel, and wants to capture his amazing physique before he gets old and flabby. Your

outdoor scene has no predominant lines, only heavy textures. Does a background with heavy textures match the style of portrait you are trying to create? Yes it does—it's your lucky day!

Let's take the same situation, but instead of the fireman wanting a portrait that shows his muscles, let's say you were told he is about to be a father and wants a portrait to someday give to his child. Again, all you have is heavy texture in the scene, and this will give a harder look to the portrait—not quite what you want for this image of a new dad! To soften the texture and produce an image that shows the softer side of this firefighting father, you simply open up the lens and increase the distance between the subject and the background.

In the same two scenarios, if the background's predominant element was lines, then you would have to look for straight lines (whether vertical, horizontal, or diagonal) for the "he-man" portrait. To create a

softer feeling for the portrait he would give to his child, you would look for the predominant lines to be curved in order to reflect the correct feeling.

Contrast. If the first element you notice in a scene is contrast, it is the lighting of the scene and not the scene itself that is drawing your eye to that area. Whether it is in the studio or outdoors, contrast in an image is created by light. Controlling contrast in the studio is easy. If you want to bring out an element in the background, you simply light it with an accent light. If a background element is receiving too much light and creating too much contrast for the desired look, you simply turn the power down—or you can use gobos to block the light from hitting that part of the background or scene.

Outdoors, you are dealing with a much larger area and a much bigger light source (the sun). You can't reduce the light in a particular area of a large scene. At best you can darken the entire background by increas-

Softening the textures in the background often creates a more appealing look—and helps keep the viewer's attention on the subject of the portrait.

When I find that a beautiful background is unusable because of direct sunlight creating hot spots and blown-out highlights, I start rotating the camera position around the subject to see if another part of the same scene is usable.

ing the light on the subject or increasing the shutter speed if you are using flash. The problem is that this darkens *everything* in the scene and you will often lose the shadow areas completely by the time you've darkened the image enough to bring down the highlight areas to an acceptable brightness.

To control this problem outdoors you have two choices: use a different scene or use a different part of the same scene. When I find that a beautiful background is unusable because of direct sunlight creating hot spots and blown-out highlights, I start rotating the camera position around the subject to see if another part of the same scene is usable. I may also change the position and height of the camera in order to isolate a usable portion of the background.

Color. The last consideration in selecting a background is to choose a color that harmonizes with the color of the subject's clothing. Some photographers'

answer to producing color harmony is to put a color gel on the background light that matches the clothing color. While this is a very simplistic way of ensuring your background coordinates with the client's clothing, it is very limiting from a creative standpoint.

When we design sets and paint backgrounds, we try to use neutral colors that will coordinate with many colors of clothing. Backgrounds and sets that are monotone (white, gray, or black) can be used with just about any color of clothing, and coordination won't be a problem.

A related consideration when pairing backgrounds and clothing is contrast. No matter what the color, if you pair up a lighter tone with a darker tone you are creating the area of greatest contrast—an area where the viewer's eye will be led. As discussed in chapter 2, this isn't always a bad thing. For example, we use white backgrounds with bright colors like red.

Often, an outdoor background has an area that is unusable. In this scene (top), the water is reflecting light from the open sky, making some very bright spots in an otherwise dark scene. To make this background more suitable, you line up the shot, moving the camera to the left or right (or up or down) until you eliminate the problem. By lowering the camera position, I was able to make the background area much more usable (bottom).

This draws the eye to the red clothing, accent piece, or area of the background. You are in control of what you create, and many clients like contrasting elements within a scene.

Of course, the color coordination of a background or scene to the client's clothing is much easier in the studio than on location. Outdoors, you can't change colors, you only have control over how light or dark the color of any given background will record. If a client wears a white or lighter tone of clothing and you are photographing her in the average park scene, you can let the background record as lighter than it actually is in order to better coordinate it with the lighter clothing. Should the client wear black (or near black) in a scene that has direct sunlight illuminating it, you will need to darken the scene by adding light to the subject or increasing the shutter speed to reduce the light on the background.

▷ Learning to Manipulate Backgrounds

Once you understand how to interpret a scene or background and understand what it says visually, you can learn how to manipulate it, making it better suit the style you are trying to produce. I am a working photographer just like you. I realize that you only have a certain number of backgrounds and sets in your studio and only so many scenes at any given outdoor location. Learning how to modify your backdrop and scenes lets you make the most of them, changing their appearance to coordinate with all the other aspects of the portrait you are creating.

Many photographers miss out on this opportunity and only take the scene before them literally. Vertical

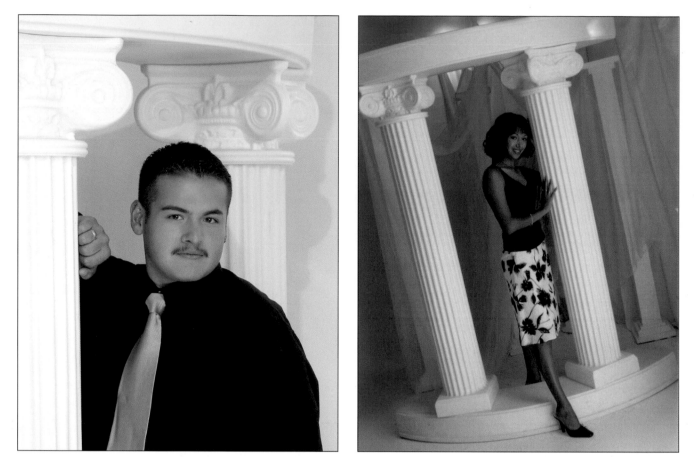

Vertical columns have a solid, classic look (left). Tilted ones have a more dynamic feel.

Using colored gels can dramatically change the look of a neutral-colored set.

Just because a background has vertical lines doesn't mean you have to use them that way—you can also try tilting to create a different look.

lines have to stay vertical, horizontal lines have to stay horizontal, and heavy texture has to stay heavy texture. Well, no, it definitely doesn't. The camera is easily fooled—and something as simple as tilting the camera slightly can completely change a scene or background. If the background has a great deal of texture but you need a softer feeling, open up the lens and the background will soften to produce the look you want.

Remember, this isn't about what you have to work with, it's about what your imagination can create. My staff at the studio calls me MacGyver, because no matter what equipment goes out, no matter what is forgotten, and no matter what rotten surroundings we are situated in, I will devise a way to produce a salable image. That's my job!

▷ Getting the Client's Input

As you've seen throughout this book, the key to selling portraits is creating images the client wants (as opposed to the images you want to create—and hope they'll happen to like, too). When it comes to backdrops and scenes, the best way to do this is to provide clients with a sample book that they can look through and pick out the types of backgrounds they want done in their session (we also do this with posing, which will be covered in chapter 7).

At this point, many photographers say, "Hey! I'm the photographer—I know what they should have." No, you don't! Clients are individuals, and to keep them happy you have to treat them as such. Besides, allowing a client to pick her own backgrounds doesn't mean that those are always the exact ideas you're going to use. You'll usually see that clients select a set of similar ideas, though, and that gives you a starting point for the session. From there, you can take her

ent to look at) and then focus on creating what they want. When you do this, you'll have accomplished two things. First, you'll improve your profits because your client will get exactly what she wants. Second, by handing over the choice of background to her, you'll also hand over part of the responsibility for the session. How many times a week do you hear, "I really don't like that pose," or "Why did you pick that background?" A photographer's ego can take a real beating answering questions like these—but when the client has selected her own background, how can she complain?

Even though the senior has selected the clothing they brought to the studio, as well as the background they want done, it is up to me to bring it all together and make the necessary changes to achieve a portrait that has a sense of style. Many clients (children, adults, business portraits, etc.) will only change once or twice, which is much easier on the photographer. As a senior portrait studio, we have to coordinate the clothing to all the other elements in the image idea six to ten times in the average session. It's a great deal of work for me, but that's what I get paid for!

▷ Working with a Digital Camera

Determining the look of any background or scene is much easier to learn with the use of a digital camera. You have an instant preview of the world around you. If you want to see what a background will look like, simply focus the camera where the subject will be standing, hold down the button (to hold focus) and then compose the portrait. You will see exactly how the scene will look and how it is translating visually. You can make any adjustments in exposure, depth of field, and composition before your client is ever positioned!

Don't be afraid to experiment and develop new ideas that suit your clients' tastes—developing a consistent style doesn't mean you don't learn, change, and evolve!

basic ideas and make suggestions as to other backgrounds that might be better suited to her (or better coordinated to her outfits). Just make sure those suggestions are based on her preferences and not your own.

I've learned that it's best to take one or two ideas in a different style (just so they have something differ-

7. Posing Choices

Once the background/scene is determined, the next step is to pose the client in such a way that it reflects the same feeling that is produced by the clothing and the scene. Most photographers never get this far in planning a portrait before they take it. You don't need days to sit and dream about the session you are about to take; you just need to be aware of what you are creating as you create it and know what the client's expectations are.

▷ Posing for the Purpose (and Buyer) of the Portrait

The most important consideration when it comes to posing is the reason or purpose the portrait is being created. Who will it be given to? A portrait that is created for a grandmother should be quite different than one created for a romantic partner.

Let's say your first client of the day is a young lady who likes very glamorous posing—she likes wearing crop-tops and miniskirts—but she is having *this* portrait taken for her father. Dear old Dad is the pastor of the local church, so I guess you could call him a traditional guy. In this situation, you can imagine that what the girl might select in terms of clothing, posing, and background ideas might not be what would be suited for her dad. How are you supposed to know this? You ask. As the professional photographer, you

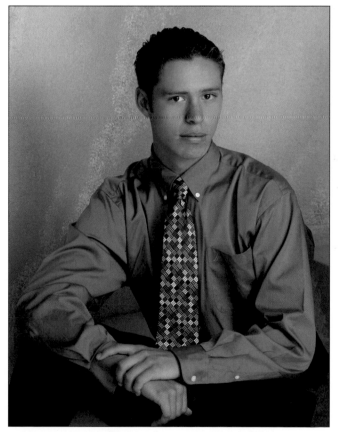

Who is the portrait being created for? An image made for the subject's grandmother should, of course, be much different than one created for his or her romantic interest.

have to get the information you need to create the type of portrait that is appropriate for its end user.

We create many styles of portraiture, all within the same session, so we have something to suit everyone's tastes. With senior portraits, we find that the seniors themselves like full-length poses, graphic backgrounds, and baggy clothing. Their parents, on the other hand, want to see their son or daughter in a head-and-shoulder pose with a classic background and a less casual outfit. To maximize our sales and satisfy everyone, we need to deliver both types of images.

This was a hard lesson for me to learn. I fell into the "photographer knows best" way of thinking for

quite some time. I would let the seniors control everything about their session. While it was fun for me and great for the senior, I was losing money without even knowing it. It wasn't until one day when I went over the sales figures that I finally realized what was going on. When you have a contracted senior studio, you have to offer mini-sessions for the yearbook. During this session, we do two head-and-shoulders poses against a classic painted background. The style of dress is mandated by the school, so most students wear a suit and tie or nice sweater. Well, when I reviewed the sales figures from these "yearbook only" sessions I noticed that there were often $500–$600

orders! This was a lot of money for a session I didn't have to spend hours creating—in fact, they were photographed by junior members of the staff!

Those numbers certainly grabbed my attention. I started going by the viewing stations where the salespeople show the yearbook sessions and go over the ordering information. Parents loved the simple, classic style of the yearbook poses. When the student argued with the parents about ordering, the parent would say, "We're coming back to do a full senior session for you, but these portraits are for me." Because of this, we restructured the way we did our sessions. We still have the seniors select their own ideas (and these still tend to be full-length poses with large sets), but after we take the senior's idea, we take a pose that is composed closer, in a head-and-shoulders or waist-up view for the parent. Since we started doing this, our orders have dramatically improved. You always want the client's input, but as a professional and business-person, you have to create something for everyone's tastes.

▷ Styles of Posing

For the purpose of coordination, you have to know what type of pose goes with what type of clothing and background. You also must know what the end use of the portrait is and what type of pose is appropriate for that use (or the recipient's taste).

For the purpose of this book, we are going to talk more about identifying the look or style of the pose than coming up with new posing ideas. For new posing ideas, you can refer to my books *Corrective Lighting and Posing for Portrait Photographers* (Amherst Media, 2000) or *Posing for Portrait Photography: A Head-to-Toe Guide* (Amherst Media, 2004), or pick up any fashion/beauty magazine or even a Victoria's Secret catalog. All of these sources have an endless variety of fresh posing ideas that fit

Changing the subject's pose can quickly change the character of the portrait.

Classic poses are simple and structured.

into the three categories of posing we'll be discussing: traditional, casual, and glamorous.

As you'll see, not everyone defines these categories the same way—our definitions all change over time, and the lines between styles of posing gets blurred more each year. We've all seen the photos of five-year-old girls ready for a pageant—they are made-up, dressed up, and posed like 25-year-old women about to go out clubbing. Keep in mind, however, that although the boundaries of good taste get stretched by some, the majority of portrait photography buyers still follow these basic guidelines. So, photographer beware!

Traditional Posing. A business portrait, a yearbook portrait, and a portrait taken of a judge would all be good examples of the use of traditional posing. Traditional posing is simple, structured, and, to me,

has very little style (but that is just *my* opinion; it doesn't stop me from doing this type of posing when it is appropriate!).

Now, what I consider traditional posing would still be considered by some very conservative photographers to be glamorous. One time I was at a seminar hosted by a photographer in their studio. As the day progressed, I befriended a few fellow photographers. One of them asked me if I was the same Jeff Smith who wrote the books. When I said that I was, more questions were directed to me than to the photographer conducting the class (this is why I hate name tags!). Not wanting to be rude or take away from the program, I told my newfound friends that I would talk to them and answer any questions they had about the books at the lunch break. At lunch, one of the photographers wanted to know how to make simple

yearbook/head-and-shoulders portraits less boring and more salable. As I was showing him some of the poses we use in the studio, the photographer conducting the seminar came by and insisted these looked more like glamour poses than poses for a yearbook.

The times have changed—"traditional" no longer means "anal." People don't have to look as though they have a stick up their backside. Guys don't always have to look stern. Shoulders don't always have to form a horizontal line across the frame, and the body doesn't always have to be squared to the camera. You get the idea, though: traditional posing is used for traditional clothing (such as suits), classic backgrounds, and for an end use that requires a subdued look (such as a business/yearbook/honoree photo). This typically isn't the type of posing to use when creating a portrait for a loved one (with the exception of seniors,

who are traditionally photographed in this style for their parents).

Casual Posing. Casual posing makes up 90 percent of the work of any photographer who wants to sell what he or she creates. Casual posing portrays a person as they are, as opposed to what someone wants them to be. I may look like an old judge in my author photograph, but that's because I am supposed to look smart and successful. Ask my kids, though, and they'll say I'm the guy who makes them laugh all the time. If I gave my kids one of my judge photos, they'd laugh all right! People who love you want to see you as you are, as a person, not what you are required to be as a professional. That's what makes casual posing appropriate for friends and family.

A casual pose is a resting pose. The head rests on the hand or arms, the arms rest on the knees, the bot-

Casual posing shows the subject in a relaxed and natural way.

Glamorous posing makes the subject look their very best and is often used when creating portraits for a romantic interest.

tom usually rests on the floor or the ground. To learn casual posing, study people as they are relaxing, watching television, or out at the park. This is the way the people who love your subjects see them, and this is the way they will want their image captured. The greatest compliment I can receive is when a parent looks at their portrait and tells me, "That's him! That's my little Johnnie!" When I hear that, I know I have created what I am being paid to create.

We have quite a few parents of seniors who are initially dead set on a having a very traditional portrait—complete with suit and tie. In the end, though, the portrait they actually end up buying is the one of their son with his guitar. That's the one that captures the essence of the person they know and love. (But some parent aren't that warm and fuzzy, so do the traditional pose too!)

Again, this isn't rocket science; casual poses work with casual clothing (jeans, khakis, summer dresses, etc.) and less structured backgrounds with softer textures. Outdoor locations are typically casual (by lack of design I guess you would say!), and are usually paired with jeans, shorts, leather jackets, jean jackets, cotton/flannel shirts, etc. To keep with the casual look of the clothing and the scene, you would seat the client on the ground.

Glamorous Posing. The last type is glamorous posing. This type of posing makes the subject look stunning. This type of portrait is usually intended as a gift for romantic interests or social peers, not usually family members—although that is changing.

Evening dress and trendy clothing styles work best with this style of posing, although very glamorous poses can be used with more casual clothing (jeans

and a leather jacket for instance) to achieve a stunning image. Glamorous posing makes each part of the body look its very best.

▷ The Six "Deadly Sins" of Posing

Once you've decided on the best style of pose for your image, there are a few things to look out for in order to ensure the best possible results. If you make sure that your pose doesn't include any of these six deadly sins, you will have a salable photograph. The trick is reminding yourself to check every pose before you take the first image.

1. Angle of the Face. I work with a lighting ratio that is approximately 3:1 without diffusion, and 4:1 with diffusion. This means that if the subject's face is turned away from the light, the shadow on the side of the nose will increase, making the nose appear larger.

If, instead, you turn the face toward the main light source, you light the mask of the face without increasing shadowing in areas of the face where it shouldn't be. An added bonus: turning the head also stretches out the neck and reduces the appearance of a double chin, if the subject has one.

2. The Shoulders, Waist, and Hips. The widest view of any person is when the person is squared off to the camera. By turning the shoulders, waist, and hips to a side view, preferably toward the shadow side of the frame, you create the thinnest view of the body—and we all want to look as thin as possible.

3. The Arms. When the arms are allowed to hang down to the client's sides, the body isn't defined. It is one mass, making the body appear wider. When the elbows are away from the body, the waistline is defined and appears smaller.

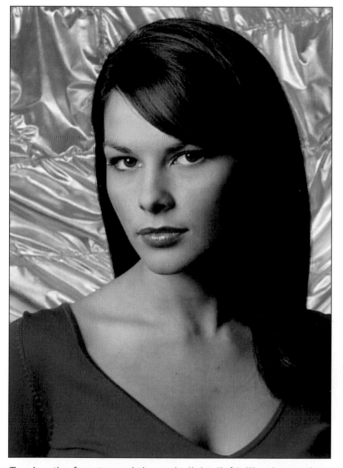 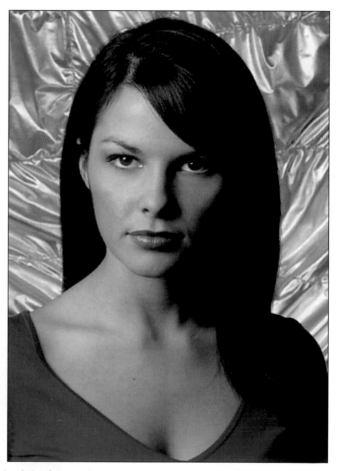

Turning the face toward the main light (left) illuminates the mask of the face and creates shadows that shape it nicely. Turning the face away from the main light (right) creates unflattering shadows.

4. Lower the Chin, Lose the Catchlights. Having no catchlights in the eyes is a problem I see in images by both young photographers and more seasoned ones. This comes from the knowledge that lowering the chin produces a more attractive angle of the face, but being too lazy to lower the main light to compensate for the pose. As noted in previous chapters, strong catchlights in the eyes are an important aspect of a portrait. Therefore, the main light should be adjusted with each client, in each pose, to ensure the proper placement.

5. The Spine and Shoulders. This could be called the "anti-stiffness" rule. When you see a portrait of a person in which their shoulders are running perfectly horizontal through the frame, or in which the spine (if you could see it) is running perfectly vertical in the frame, the person in the portrait appears stiff. Visually, you are telling everyone who sees this portrait that your client is uptight and very rigid.

By posing the person reclining slightly backwards or leaning slightly forward, you can make the shoulders and spine go diagonally through the frame and create a more relaxed look. The portrait will have a professional look and it will be more visually appealing. It will also create a more flattering impression of the subject's personality.

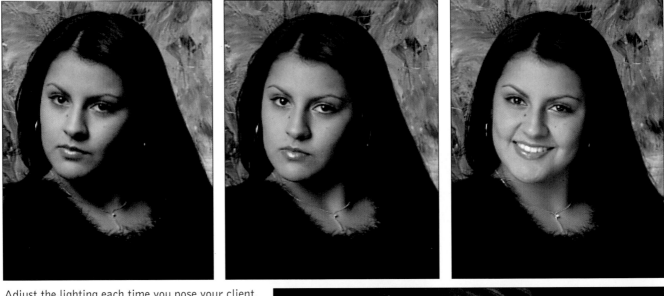

Adjust the lighting each time you pose your client. Raise the main light to a point that is obviously too high, as shown in the top left photo, which has heavy shadows under the eyes and nose, a dark shadow on the side of the face, and diminished catchlights. Slowly lower the light until the effect is what you are looking for (top center). To complete the lighting, add the reflector underneath the subject bouncing light up onto the face (top right). To the right, the setup for this image.

When you want a smile on the subject's face, you should smile and speak in an upbeat voice (left). When you want a more serious expression, use a more subdued voice and don't smile (right).

6. Your Expression. This is by far the most important of the rules. The first "photography saying" I heard was "expression sells photographs"—and it's true! You can have the perfect pose and the perfect lighting, but if the expression doesn't meet the client's expectations, you won't sell the portrait.

Again, this is another area where photographers think they know best. Most photographers like serious expressions with the lips together or glamorous expressions with the lips slightly separated. Among the public, however, mothers are the dominant buyers of professional photography, and they like smiles. Women tend to be the decision makers about photography, and they generally like portraits where the subjects (whether it's their kids, their parents, or their neighbors) look happy. Happy sells.

Many photographers have a problem getting subjects to achieve a pleasant expression. Often, the prob-lem is rooted in a concept called "mirroring." When you smile at a person, they smile back, and when you frown at a person, they immediately frown back. People will mirror the expression that you, as the photographer, have on your face.

Our attitudes and outlooks on life set our expressions, and sometimes this gets in the way of making our clients look their best. We had one photographer with us a few years back who smiled all the time. He was great at getting clients to smile, but he would frustrate clients when it came to creating nonsmiling poses. He would tell the client to have a relaxed expression (nonsmiling), while he still had a huge grin on his face. Many clients would get mad and ask how they were supposed to be serious while they were looking at his big, goofy smile.

A photographer we had before that couldn't smile to save his life. He would look at the client with a

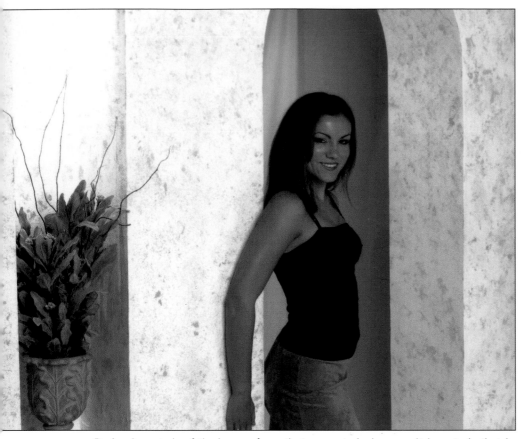

Posing is a study of the human form that never ends, because it is a study that is always changing.

are the young photographers and the older, "well-seasoned" photographers. Both tend to pose a client to meet their own expectations and not the client's. If you pose clients in this way, they will never be as happy as they could be, and you will never profit as much as you could by learning to pose for the client and not yourself.

An Additional Factor: The Tilt of the Head. The tilt of the head isn't listed under the six deadly sins, because 90 percent of the time when you have the client turn their head toward the main light, the angle of the head will be close to the correct position. The only time the head needs to be repositioned is when the client is extremely nervous. Then you will find that the top of the head

deadpan expression and, with a monotone voice, say, "Okay, smile big now." As you can imagine, the clients' expressions suffered as a result.

Mirroring isn't just about visual cues like your expression, it also involves the way you speak. When you are looking at the client with a smile on your face, speak with energy and excitement in your voice. When you want a relaxed expression, soften your voice. In this way, you are in control of every client's expression. Understand the expression your client wants, then take control and make sure that you take the majority of poses with that expression.

Although many of these rules are basic for some photographers, we have to start somewhere. Posing is a study of the human form that never ends, because it is a study that is always changing. From my experience, the photographers that have the hardest time with creating posing that meets clients' expectations

slowly starts tilting toward the higher shoulder. Photographers fresh from photography school think this is a good thing, but it is not. The head naturally tilts toward the higher shoulder because the client feels awkward and uneasy. Their body is trying to tell you something. Think about it—if people tend to pose this way because they feel awkward or nervous, then why on earth would you pose someone this way on purpose?!

▷ Show, Don't Tell

As I've mentioned before, we have each client select the background and poses they want done in their session. These ideas are written on the client card for the photographers to follow. With each pose, the photographer is to demonstrate the client's selected pose, as well as show the client at least three other variations on the pose.

Male photographers hate this. I have heard it all—"How am I supposed to pose like a girl?" or "I feel really dumb!"—but I don't care how they feel. Until you can pose yourself, feel the way the pose is supposed to look, and demonstrate it to a client, you will never excel at posing.

Yes, you get some pretty strange looks when you're not a petite man and you're showing a girl a full-length pose for her prom dress, but that is the best learning situation I, or any other photographer, can be in. Once you can consistently demonstrate poses and make yourself look good, you have started to master posing.

▷ Take Control

As I've noted throughout this book, you really need to understand what you are creating to be able to plan your client's session appropriately. If you just go into the camera room and zip through your five favorite poses with every client, you lose and they lose. When you take control over your images, you can better produce exactly what your client is looking for. It's at this point that you can consider yourself a professional. You will also find that, when clients are truly satisfied, your bank account will grow with your ability.

To show this concept in action, I've created the following series of images using the same subject in different styles of clothing and tracking the session from her arrival at the studio.

In the first image (top), the client has arrived at the studio and is looking through our books to select the types of poses and backgrounds she would like. Next, she works with one of the staff members to coordinate her outfits to match the poses and backgrounds she has selected (right).

Some images from her session are presented on the following pages. Notice how the background and posing changes as the clothes change, ensuring that each part of the portrait makes sense.

8. Lighting Choices

I have developed a style of lighting that I and my clients like (which I will explain in a moment). For 95 percent of the photography at my studios, we use this type of lighting—refining it for each client, of course. The other 5 percent is specialty lighting that is used to create a specific look. We use various spots, butterfly

lighting, and assorted parabolic lights for those clients who select these lighting effects out of the sample books.

The lighting style of my portraits isn't important here (you may like it, you may hate it)—my clients like it and are willing to pay for it, and that brings my family much happiness! What is important is that we achieve that same style of lighting through each of our thirteen camera areas, for everything from head-and-shoulders yearbook poses to three-quarter- and full-length poses. I also use the same style of lighting when I am photographing seniors at outdoor locations. We achieve this consistency by understanding lighting characteristics.

As you read through this section, keep in mind that your goal should not be to copy another photographer's style (mine). Instead, do some samples, show some clients these samples to get their feedback, then

If your clients like your lighting and are willing to pay for it, that's what's most important.

sit down and think about how you want your photographs to appear based on what will be marketable to your clients.

What We Use and Why

In our studio we have five different camera areas. These are: the area where we do our yearbooks; a head-and-shoulders bay; a high-key area where we use exclusively high-key sets; a low-key area; and an area in our warehouse where we use our larger sets, including my Harley.

In the yearbook area, we use a simple lighting setup that is very forgiving to both the subject and the photographer. Because the yearbook area is used by the least experienced photographer in the studio, we need a completely repeatable process to ensure that each senior's background is the same as the next.

With the switch to digital, we've switched the light modifiers we use (as anyone who has read my previous books will quickly notice). In the days of film, we created our full-length portraits using a 72-inch Starfish for the medium-sized sets and a 6-foot Octabox for our largest sets.

Why did we switch? Well, learning is a never-ending process—even if it's not intentional! One day, a staffer pulled out all the old light boxes and equipment that we no longer used so that we could get them listed on eBay before they were ruined in storage. We had a variety of Photoflex light boxes with louvers. As I was photographing the light boxes for the auction, I had a session start, so I used the largest light box with louvers in the warehouse area. When I saw the photographs from the your lady's session, I really liked the added contrast of the light from these boxes. I ran some tests to compare these modifiers to the Starfish and the Octabox. Using digital, I felt that the lovered boxes improved the overall look of the photographs and also gave the eyes much more detail when enlarged.

In our warehouse area, we use our larger sets—including my Harley, which you'll see in a number of the images in this book.

What has not changed is that we still use the Wescott Tri-Fold reflector under the subject in the head-and-shoulders area, and a 30x40-inch light box on the floor in all of the full length areas. This adds a glamorous look to the lighting.

Positioning the Lights

Main Light. The angle of the main light is always determined by the orientation of the subject's nose. With the subject's nose pointed directly at the camera, the main light should be at approximately a 45-degree angle. To add shadow or bring out more facial structure you may increase the angle of the light, but this is the angle at which most portraits will be taken. The great thing is that the light always stays at a 45-degree angle to where the nose is pointing. Even when you go to a profile, the light still remains at a 45-degree angle to the direction in which the nose is pointing.

If you aren't good with angles, you can figure that with the nose pointing forward, if a line were drawn out directly from the ear, that line would be at a 90-degree angle (or one-quarter of a 360-degree circle). In this same situation, if there were a line coming directly out from the edge of the subject's cheekbone, that would be a 45-degree angle. As long as the light stays at approximately this angle, no matter where the

nose is pointed, the effect on the face and eyes will be beautiful.

Fill Light. Once the main light is in position, you have to decide on how much of the shadow area needs to be filled. Start with no fill at all. If the portrait looks great, don't add any fill. Somewhere along the line, you were probably told (like I was) that you have to see some detail in the shadow area. Wrong! If a shadow that goes black is what makes your subject look his best, then that is the perfect lighting to use on that individual client—remember, people buy portraits that make them look good. Most of the time, however, some fill is necessary to bring the shadows to a printable level.

At this point, many photographers are waiting for me to explain the lighting ratio I use and why I use it. If I told you I use a 3:1 lighting ratio for undiffused portraits and a 4:1 ratio with diffusion, what would

that mean to you? Many photographers are thinking this is a stupid question. A ratio of 3:1 is where the main light is 1½ stops more than the fill; 4:1 would be with the main light two stops more than the fill, right? Well, not quite.

Lighting ratios are a simplistic approach to a very complex subject. Let's go back to photography class. Imagine I gave you two balls to photograph—one was white and the other was a dark gray. Next, I asked you to create a photograph of each ball that produced a shadow with detail. Could you accomplish that with the same lighting ratio? Nope. To create two photographs with the same shadowing and detail in the shadow, you would have to use different lighting ratios—otherwise the shadow on the gray ball would be darker than the one on the white ball. If any photographer tells you that they use the same lighting ratio for all their clients, they either 1) live in the only

It's a plain and simple fact: people buy portraits that make them look good.

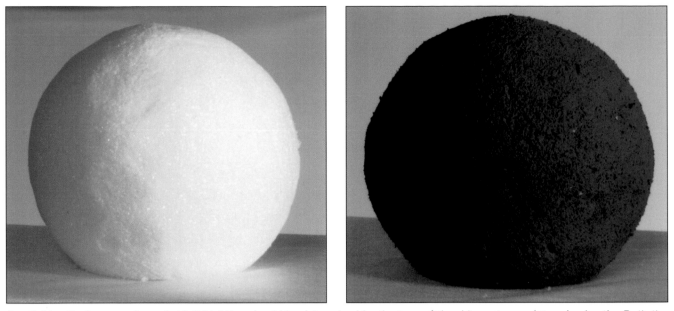

One light ratio for every type of skin? Lighting should be determined by the tone of the skin, not a predetermined ratio. Both the white ball and the gray ball were lit with a 3:1 ratio. As you would suspect, the white ball has a wider transition from highlight to shadow—and the shadow has detail. The gray ball has a smaller transition and no shadow detail.

town in America where all the clients have the same skin tone, or 2) fail to produce consistent shadowing for their clients because they all have different shades of skin. What do you think?

The next question you probably have is, "How do you know the right amount of shadow?" The answer is simple: you run tests on different skin tones to see what the correct ratio of lighting is for varying darknesses of skin. Then you know what will produce the look you want. There is, of course, one other way to determine the correct amount of fill, and that's to train your eyes to see shadow in the same way the camera will. How do you do that? Practice, practice, and more practice. Eventually, you will be able to tell how much the shadow needs to be filled by the way the shadow looks. I personally like using reflectors to fill or create my shadow. This way, once your eyes are trained, what you see is what you get.

You might be wondering why we choose reflector fill. Like all young photographers, I was taught that you use a flash to fill the shadow. You put this enormous light source at the back wall of the camera room—a light that literally fills your entire camera

room to a certain level of light. I was then instructed, as most of you were, that to avoid flat lighting you should use a ratio between the main light and fill of 3:1 without diffusion and 4:1 with diffusion.

I worked with this for quite some time. It wasn't until a young African American woman came into my studio and talked with me about doing her portraits that I saw a problem. She asked me if I had ever photographed an African American person before. I thought for a minute and realized that I never had.

Now, I started studying photography when I was fourteen. I did my first wedding when I was sixteen and opened my studio when I was twenty. This incident occurred right after I opened my studio in the small town that I grew up in. I went to school in this small town from fourth grade through high school and there were probably four African American students in our school system in all those years. Although this town didn't have many African American people residing in it, it did have many people with different ethnic backgrounds, and all shades of skin color, which I had always photographed in the same fashion and with the same lighting ratios.

I tell this story not to bring up the differences between all of us, but because when this lady asked me her question, I realized for the first time how limiting the use of fill flash was. My first thought was, "Wait a minute, I use a 3:1 or 4:1 ratio, but that's for a light skin tone. What ratio do I use for the other shades of skin—all the other shades of skin?" I then asked why she would ask me that, and she explained that she had had her portraits taken several times, at several places, and they just didn't look right. She said they had very heavy shadows.

Well, I did the session, but I did it with a reflector for fill so I could see on her face, with her skin tone and facial structure, how much shadow or fill I wanted. She loved the portraits, and I learned a major lesson. You can know what the ratio of lighting is by metering, but when you use a flash fill you will never know what the "perfect" ratio of light is for each individual's skin tone and facial structure—until you see the proofs.

In this country we have a variety of people from different countries, with different shades of skin, and different facial structures. The only way to evaluate the right amount of fill is to see it with your own eyes. There are some of the old masters who use flash fill and create some breathtaking images doing so. But these photographers have been using this lighting for years, and have become very gifted at determining what the correct ratio of light will be for an individual client's skin tone and facial structure. I don't know about you, but I didn't want to take twenty years to master the lighting I use.

If you don't believe that skin tone makes a difference, photograph three people with the exact same

People have different shades of skin and different facial structures. Therefore, the only way to evaluate the fill light is to see it with your own eyes. That's why we use reflectors as our fill source.

light on them and the background. The only difference should be in the three subjects' skin tones. Select one person who is very fair, one with an olive complexion or a great suntan, and one person with a very dark complexion. When you get your proofs back, you will see the difference in the backgrounds of all three people. The very fair person will have a very dark background, the olive or suntanned person will have a background that is normal, and the person with the dark complexion will have a very bright background. It just goes to show how important making conscious decisions is to creating great images—there's no formula that will work for every subject or every shot!

Separation Light. With the main light and fill reflector in place, separating the subject from the background becomes the next step. Again, there are no rules. You have one objective and that is to make your client look as good as possible. Remember, no background or separation from the background

means no point of reference behind the subject. No point of reference behind or in front of your subject means no depth in the portrait.

We have a strip light attached to the ceiling in our low-key and yearbook areas. This gives a soft separation to the hair and shoulders when the light is metered at one stop less than the main light. When the client has long hair we typically use two accent lights mounted on the back wall at about 6-feet high. These are angled inward at a 45-degree angle to the subject. This light adds a lustrous look to the sides of the hair (and women with long hair want it to look shiny!).

We also add a light we refer to as a "halo" light. This is aimed toward the hair behind the subject. This creates an intense rim light all the way around the hair. The side accent lights meter the same as the main (lights tend to pick up intensity when aimed back toward the camera). The intense halo light meters one

The unit we call a "halo" light is used to create a bright rim of light all around the subject's hair.

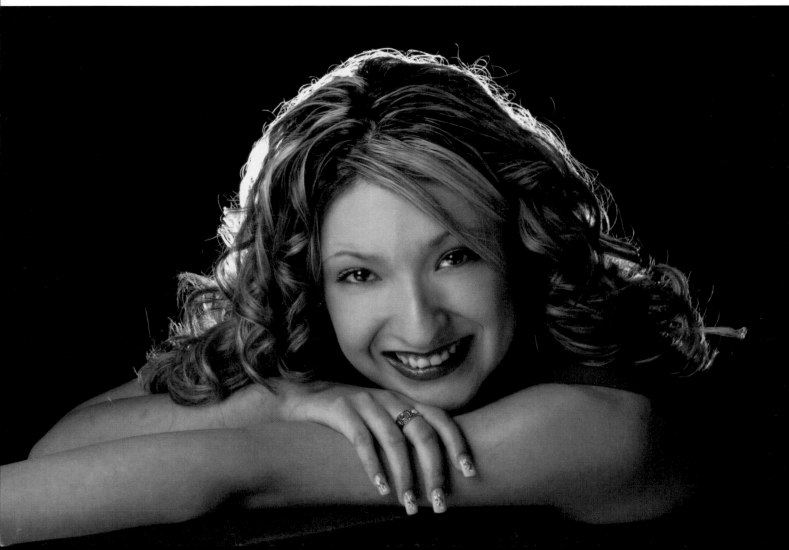

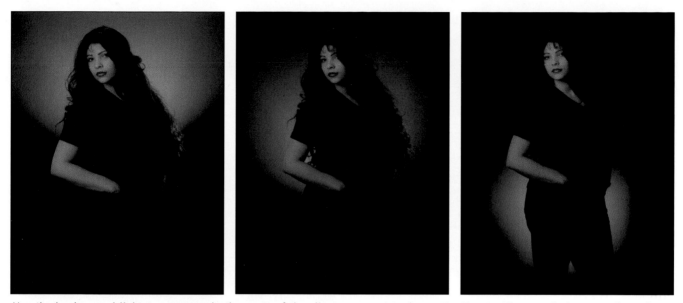

Use the background light to accent only the parts of the client you want to draw attention to. Three variations are shown here, with the light placed near the head and shoulders (left), upper body (center), and lower body (right).

stop more than the main for blond hair and three stops more than the main for brunette or black hair.

Background Light. Where the background light is directed and the intensity of the light will greatly determine what part of your client is separated. Keep in mind that this will draw the viewer's eye to that part of the body. With the background light low and the subject standing, you separate the hips and thighs from the background (the same hips and thighs that you know your client will worry about looking too large). By raising the background light to waist height, the waistline and chest area are separated and become more noticeable. Elevate the separation light to the height of the shoulders and only the head and shoulder will be separated, leaving the body to blend with the background.

The greater the intensity of the background light, the more attention it draws to whatever part of the body it is separating—unless the subject is wearing lighter clothing. Often a client will select a dark background and want to wear lighter clothing with it. In this situation, by increasing the background light to match the brighter tone of the outfit, you will actually lessen the attention that is drawn to this area.

Whenever weight is an issue and the subject has long hair, we leave the background texture as dark as possible and put a light directly behind the subject facing toward the camera to give the hair an intense rim light all around the edges of the hair. This draws the attention directly to the facial area and keeps the viewer's eye away from the shoulders, arms, and upper body.

▷ Size Matters

Keep in mind that the size of the light boxes you use should be determined by the distance the light will be placed from the subject. We find that a medium-sized box is perfect for working in our head-and-shoulders area, but a large or extra-large box needs to be used when working in the full-length areas, where the light has to be placed farther from the subject.

By selecting the size of the light box in this fashion, you achieve a consistent lighting style as you go from one end of the studio to the other. After all, if you can't match the quality of lighting between very controlled shooting areas in your own studio, you have little chance of developing an consistent overall style.

▷ Grid Spots for an Alternate Look

In high school senior photography, the use of spotlights has been popular for many years, especially for portraits in black & white. The hard, contrasty lighting produces a very theatrical feeling. Spotlights also have the ability to focus the viewer's eye precisely where you want it to go. When used as a main light, the beam of the spot leads the eye to the facial area, while letting the rest of the body fall off into shadow.

In the studio, we use grid spots in three different ways. Often, we simply use a single grid spot as the entire lighting for the portrait. A very popular idea for seniors is to set the subject up against a white wall and let the heavy shadow of the subject projected on the wall provide a dramatic background. In using the grid spot as the only light source, you have to watch out for the creation of deep shadows on the face. While dark shadows look good in the background, on the face these heavy shadows can be quite unsightly. The easiest way to handle this is to turn the face more into the spotlight and work with the spot at no more than a 45-degree angle from the camera. Using the spot in this way gives you the greatest contrast and the most options for hiding flaws.

The second way we use grid spots in the studio is to replace the main light with a grid spot. When we do this, we also continue to use the light from a lower angle (like a 30 x 40-inch soft box on the floor). This lighting has a beautiful quality but has more contrast than the 72-inch Starfish alone. It is also much more controllable. The grid spot is set to read at 1½ to 2 stops more than the 30 x 40-inch soft box on the floor.

The third use for grids in the studio is as an accent light working with the main light to draw attention to the face. Simply put the sphere of light on the facial area after your normal lighting is in place. The spot should be ½ to 1 stop more than the main light, depending on how noticeable you want the light from

The contrasty light from a grid spot produces a very theatrical feeling.

the spot to appear. This little bit of light helps smooth the complexion, but more important is the effect it has on the color of the eyes. If you can see any color around the pupil, this accent light makes it much more vibrant. Anytime I see someone come in who

has colored contacts or color around the pupils of their eyes, I do at least one of their poses with this accent light.

No matter how you use grid spots, they give you the ability to offer your client different styles of lighting that create different image styles. A photographer who can only offer his clients one style of lighting or one style of portraits, can only appeal to one type of client with one type of taste.

▷ Outdoor Lighting

Outdoors, I want this same style of lighting that I produce in the studio (again, the idea of consistency is important). I don't know why so many talented photographers have a beautiful style of lighting in their studio, but when they go outside, they act they are lost. They strap their Vivitar or Sunpack flash into the camera's hot shoe and blast it in the subject's face. They destroy all the beautiful light that exists naturally. If this is what you do, save yourself some time—set up a green screen in your studio and get Express Digital software to put the outdoor backgrounds over the green screen. At least your clients will have portraits with high-quality lighting.

When I am working outdoors, I look for natural light to produce a lighting effect that matches the look of my Starfish in the studio. To do this, I study the subject's eyes. Outdoors, the eyes will tell you everything you need to know about your lighting. After I find my main-light source, then I use a large reflector under the subject to replace the trifold reflector I use in the studio.

In my book *Outdoor and Location Portrait Photography* (Amherst Media, 2002), I talked about using gold reflectors and working in shaded areas without flash. I wrote this book when we used film. (These were the good old days—when you could stroll through the outdoor locations and not worry about subtle variations in the color of light because the lab

would match all the colors for you.) With digital, we never use a gold reflector beneath the subject (for the same glamorous look we create in the studio) because it turns the subject yellow. Instead, we use a silver one.

To save our people in the studio from having to match the skin tones from one outdoor area to another (because with digital, I am paying for the time to do this now!), I use flash to fill the shadow and eliminate any color casts. On the subject of color casts, we always reset the white balance of our digital cameras when we start shooting in a new area. We don't use the automatic white-balance setting that all digital cameras come with; we tried that and found that our skin tones were all over the place. Certain colors of clothing dramatically affected the white balance and, in turn, the skin tone. I say "dramatically," because *I* was the guy paying for the computer people to color

Outdoors, the eyes will tell you everything you need to know about your lighting.

correct the skin tones and getting it all to match—and even small shifts require time and money to correct. Once we started manually setting the white balance in all of our cameras, in all of our shooting areas, the time we needed to spend color correcting our images dropped by 30 percent. Considering our volume, that means we were wasting a lot of time and money using the auto setting.

▷ Shadowing

Shadows go hand in hand with lighting. Consistency in shadowing is achieved in

Do your clients like a dramatic look? Do they prefer lighter, more open shadows? Understanding this is critical to developing a profitable style.

different ways, depending on whether you are working in the studio or outdoors. In the studio, you typically have to *fill in* the shadows; outdoors, you typically have to *create* the shadows.

In the studio, you have directional lighting—even if the light you are using is very soft, it has direction and creates shadow. The size and darkness of the shadow depends on the softness of the light (which in turn depends on the size of the light source and how far that light source is away from the subject). To increase the shadowing on any subject, simply pull the light away from the subject and the light will become more contrasty, increasing the shadowing. To decrease the shadow, you have to add light to fill it. As noted above, you can fill the shadows with light from a strobe or you can fill it with light bounced out of a reflector—the choice is yours.

When working with natural light outdoors, your light source is so large that you often have to create a shadow by blocking some of the light. To do this, you can look for a grove of trees, a building, or, if all else fails, you can use a black panel.

Whether you are in the studio, or outdoors you must determine how much shadowing you want. Do you want to see detail in the darkest shadow areas or

do you/your clients like a shadow without detail for a more dramatic look? It is *your* style, but it's *your client's* photograph—something they must live with for the rest of their lives—so choose wisely. To ensure a consistent look in your studio and outdoor photographs you need to look for similar shadowing in both situations.

Keep in mind that your eyes can see detail in the shadows that neither film nor digital files are capable of recording; they don't have the tonal range, the range of colors from the brightest highlight to the darkest shadow, of human vision. Photographers who were used to the tonal range of film are now having to get used to the way digital files capture the tonal range in our scenes. Film provided a good transition from highlight to shadow. It recorded the actual skin tone and the varying densities of that skin tone color all the way down to black or near black. With digital, the transition area from highlight to shadow doesn't have the smoothness that we saw with film. As the skin darkens from highlight to shadow, the actual skin tones tend to pick up other subtle colors in its transition to black. To me, it looks greenish. This is just one of many little quirks of working with digital files. We typically correct this transition area in retouching.

9. How It All Comes Together

You have spent the past hours, days, or weeks (depending on how quickly you read!) learning about the various elements of a portrait and how each element is coordinated to another to achieve a final image that makes sense visually. Now, we will discuss how to use this information.

▷ Before the Shoot

Preparing the Client. As you learned in chapter 3, we go out of our way to inform each client of exactly what to bring to their session to get the best results in their portraits. When a client arrives for her shoot, my staff greets them, writes down their ideas, and then brings them and their clothing back to me.

Evaluating the Client and Their Needs. The first thing I do is look at the client from the top of their head to their feet to see what I am going to have to do in the session. I look at them and say to myself, "If I were them, I would want to change X, Y, and Z." This sounds mean, but I know that clients don't want to see their imperfections. It's a simple rule of photography: hide problems, make a big sale; show problems, make no sale!

With those problem areas in mind, I start by looking at the client's clothing and pairing up the outfits with the selected backgrounds. If a background is selected for which the client has no appropriate clothing, or if the client brought clothing that doesn't suit

It's a simple rule of photography: hide problems, make a big sale; show problems, make no sale!

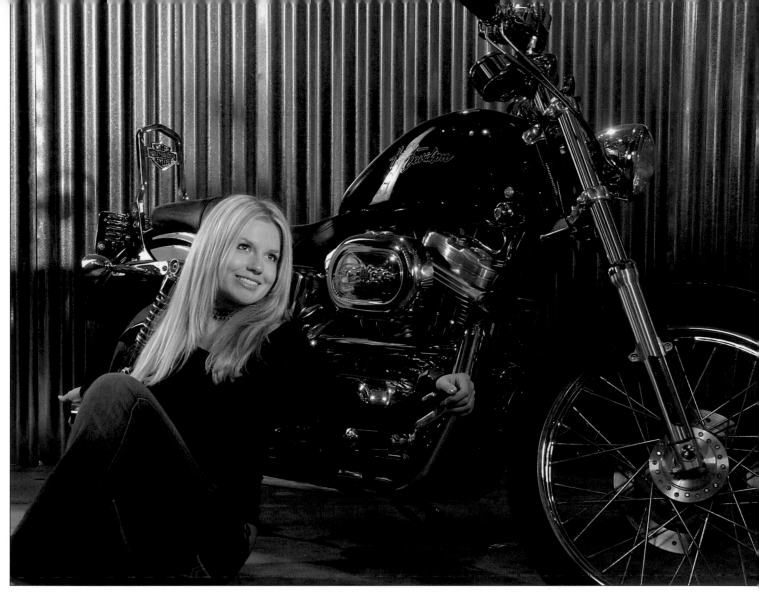

Before the client ever comes out of the dressing room, my staff has everything set for them to begin.

their body type, I address the issue at this time. I often show them other backgrounds that will go better with the clothing they have or politely explain (as discussed previously) that the clothing they have is better suited for a different pose than the one they selected.

Preparing the Set. Once the clothing is paired with each background/set idea, we then start preparing the set for the client. At this time, we adjust the set to best coordinate with the client's clothing. This may mean adding a different chair, changing columns, adding foliage, or using color gels. We also get the lighting set for the hair and body type of the client. Longer, curly hair requires more accent lights and a larger coverage than short hairstyles. A person with a

trim waist will want a separation light at the waistline when in front of a darker background to define that area; someone who isn't thin will not want this area clearly defined.

▷ The Shoot

Studio Images. Before the client ever comes out of the dressing room, my staff has everything set for them to begin. They tell me when the client is ready and what pose they have selected. If the pose works with all the other elements of the portrait, that is the first pose I demonstrate for them. If not, their selected pose is mixed in the middle of the three to seven pose variations I show to the client (see chapter 7 for

more on how we demonstrate posing). I explain the benefits of each pose and the overall look, steering them toward the ones I think will be most flattering for them.

After the client selects the pose, I then help them into it. Once they are in the pose correctly, we fix their hair and straighten their clothing. At this point, we adjust all the lighting and reflectors to give us the look we want and the look that is best for the client. The final adjustment is always the main light. I look into the subject's eyes as I place the main light, as well as the reflector or light underneath the subject. I want strong catchlights for both light sources, and I want them to be of equal size in both eyes.

Finally, after all of this, I pick up the camera. This is an important point: the reason I am successful is because I spend more time *thinking* than *photographing*. Go back through this book and look at all the

The camera cannot produce an image with a sense of style, and a camera can't evaluate your client's tastes and expectations—only you can.

steps that are involved in the photographic process *before you ever touch a camera.* Why is planning so important? The camera cannot produce an image with a sense of style, and a camera can't evaluate your client's tastes and expectations—only you can. If every photographer put this kind of forethought into the creation of their images, the income and professionalism of photographers as a group would soar. Sadly, there are a lot of photographers who never take the necessary steps to prepare a client for their session, let alone plan each aspect of the photograph to visually make sense. This is the difference between success and failure—creatively and financially.

Outdoor Images. Outdoors, the session is a little more complex. First of all, I don't have a full staff. Instead, I have one or two assistants who help me photograph the day's sessions. Since travel to and from a location is what makes outdoor locations less profitable for most studios, we schedule entire days at a single location. We can see up to twenty people at one location in one day. To make this work, we became skilled at working with the changing light at different times of the day.

When I am outside, I am constantly walking around the various scenes at the location. Watching the changing light, I am always evaluating what I have to work with before the next client shows up. Once I know the scenes that are available, I talk with the client about their clothing and decide on which outfits will work with the areas that are available to use at that given time. I also consider the order of the clothing so we don't loose the light in a desired area before their session is over.

As the client is changing, we prepare the light modifiers that we will be using. If I am unsure that a background or scene will work with an outfit, I compose and focus on the spot where the client will be posed to see exactly how the scene will look. I examine the tone of the background. If I am photograph-

Before posing a client, I look at the direction of the hair flow for long hair and the best side of the face/hair for short hair.

ing a young lady in a white dress and the background is darker in tone, I will allow the background to step up to a higher key to better coordinate with the dress. If the background has hot spots, caused by the intense midday sunlight, I look for a way to hide or conceal these problem areas so they won't be seen in the final image.

Before posing a client, I look at the direction of the hair flow for long hair and the best side of the face/hair for short hair. I look for accents on the dress, any problems with the fit of the clothes, jewelry that the client will want to see, and note whether any area of the body needs to be hidden or softened. All these things will determine the direction in which

I pose the client, as well as the poses I will show her to select from. Each change in direction will have a different look.

Once we have a client in a pose, I look to see if any part of the client should be hidden from camera view to enhance their appearance. I often break off branches from trees to have my assistant hold in front of a problem area or position long blades of grass to cover problem areas like neon toenail polish. At this point, it is time to take the picture.

▷ It Only Adds a Few Minutes

After reading about how I conduct my outdoor sessions, you must think I work myself to death or pho-

The more you focus on the details and controlling everything in the image, the faster you will get at achieving control.

tograph only a few people a day. In fact, we can see up to forty seniors a day in our studio! As I mentioned earlier, outdoors we work with twenty people on a single location-shoot day. Additionally, keep in mind that these are seniors, so each client is changing outfits several times during the course of their session.

Having an eye for detail and providing our clients with the personal touch of having me demonstrate poses only adds a few minutes to the average session

and is a must for controlling the outcome of the images we create. Your mind and your eyes can work very quickly once they are trained to do so. The more you focus on the details and controlling everything in the image, the faster you will get at achieving control.

▷ More Than Just Photography

Being a professional photographer is more than just knowing photography. It's the same in any field—chefs must know more than how to cook and lawyers must know more than the law. I'm successful, not because I am the world's best photographer (because I'm sure that I'm not), but because I am a good businessperson and I have an understanding of what my clients truly want—and what is in their best interests. I also understand that my success is completely determined by what I know and has nothing to do with a piece of equipment or ideas from another photographer. In my opinion, one of the most important parts of my success is having overcome the false assumption that as a business owner, I answer to no one (as many employees think is the case). As a business owner I answer to *everyone*—including my employees. The greatest hurdle to overcome as a creative, independent businessperson is to realize that your vision of what you are creating is secondary to what the client has envisioned.

The process of creating an image that stands the test of time isn't an easy one, but believe me when I say that it is far easier than having to face your clients if you don't! This point bring us to our next chapter, which deals with the choices you make when presenting your portraits to clients.

10. Portrait Presentation Choices

There are two parts of presentation. The first is the way in which you prepare your product for delivery. How is it printed, how will it be displayed, how is it packaged to give to your client? The second part of this is the way in which you present your images to your clients.

▷ Presenting Images to Clients

How you present your images to clients will have a direct impact on the profit in your pockets. I feel so strongly about it that I wrote an article on the topic for *Rangefinder* magazine. The article was called "Paper Proofs are for Wimps"—and for good reason! Although so much has changed in photography, the majority of studios in this country present their work to clients in the same way they've been doing it for the last sixty years. What has kept paper proofs as the chosen method of presentation? One word: fear—fear of presenting your work to your clients and actually hearing what they have to say; fear of learning to sell the product you produce (or having to hire a qualified salesperson to sell it for you)!

What's the Value of Your Work? You go into a jewelry store and ask to see three small diamond rings for your daughter. After looking for a while, you just can't make up your mind. So, you ask the salesperson to bag up the three rings because you need to take them home to have your spouse help you decide on

Although so much has changed in photography, the majority of studios in this country present their work to clients in the same way they've been doing it for the last sixty years.

Clients put everything off as long as humanly possible, it's human nature.

which one is best for your little girl. You tell the salesperson you don't mind leaving a $75 deposit, but it better go toward the purchase when you return that $1500 worth of jewelry.

After you have the rings out for two weeks, the jewelry store calls you to see if you are ready to return them. You explain that you have been really busy, but sometime in the next few weeks you will stop by the store. After four weeks go by, they call you again, explaining that if you don't return the rings, you will lose your deposit. Now, you're upset because the jewelry store is starting to act like you intend to keep the rings and not pay for them. You assure them you are going to buy one of the rings and you will be in with-

in the week. Another two weeks goes by and now the salesperson is really mad. She calls and leaves a message that you have lost your deposit and, if you don't return the rings immediately, your account will be sent to a collection agency.

Selling a product in this manner creates such a nice relationship between the buyer and the seller, doesn't it? Who do you blame for this situation? The client? The jewelry store that let something of great value leave their business? Most photographers would say the client, of course. Wrong! Clients act like clients. They (and everyone else in the world) put everything off as long as humanly possible, it's human nature.

Jewelry stores would *never* think of selling their product this way, because they know the value of what they sell. Photographers sell their products this way because they doubt the value of the product they have to sell. When you doubt what you have to sell, you avoid selling at all costs. You leave proofs on the counter and run the other way. I know some photographers who mail proofs to the client's home. How badly do they want to avoid selling to do something like that?

Why Are Paper Proofs Still Around? The first question that has to be answered is why paper proofs are still around. Is it because the client expects them? Or is it that photographers refuse to learn to sell their product? National and mall studios have used instant previewing for years with great success. As a matter of fact, without the impulse buying that instant previewing offers, I think they would be hard pressed to sell the packages they do. These studios explain that they don't offer paper proofs, and yet they still have customers. By the lines I see at Christmastime, they have quite a few customers!

A limited number of professional photographers have used instant previewing systems over the years and found that their sales averages went up and the

number of clients not ordering from their sessions went down (provided a qualified salesperson showed the images to the clients). At our high-volume studio, our senior counts aren't in the hundreds, they are in the thousands. With film, the only means of dealing with our volume was using paper proofs and a sales appointment in the studio. Clients could take the images home for a short time with a deposit. About 35 percent of the clients returned with their proofs on the original sales date. Approximately 45 percent ordered over the next six months of the school year, prompted by various reminders and deadlines for Christmas and graduation. Nearly 20 percent of the seniors/parents kept their proofs beyond their graduation day. After countless mailed reminders and notices, as well as several phone calls, they ended up in collections.

This meant that each year I could count on almost 20 percent of these families not returning to our studio for their other kids. Some photographer would think of this as a good thing, "They are stiffs anyway—we don't need clients like that!" Not being quite as negative, I realized that most of this 20 percent were not trying to get something for nothing or to rip me off. They simply realized they could put off the buying decision until later, and later never came. The money they had planned on using for portraits was used for something else or something changed in their financial lives, making it impossible to order senior pictures. Financially, nothing lasts forever. This family's economic slump would probably be over by the time the next senior was of age. However, because of the unpleasant relationship with my studio (going to collections), that upcoming senior would go somewhere else.

This is one of the many benefits of clients knowing they will view and order immediately after the session. If a client can't afford to order at the time of the

How you present your images to clients will have a direct impact on the profit in your pockets.

When the studio went digital, I saw the perfect opportunity to do away with paper proofs once and for all.

proofs once and for all. After looking at the total cost of shooting digital, I realized that the time involved would make shooting digital more expensive than shooting film. I knew I had to increase the size of my orders and the number of my orders to cover the additional costs.

I remembered that, back when I first opened my studio, I was confronted with the same problem. I had a certain number of sessions each month. To pay my bills, as well as have money to live on, I needed to generate more money from the clients I had. At that time, Charles Lewis and other photographers were talking about using Trans-Vues, which were 35mm transparency proofs produced by our lab from negative film. We designed a sales room that looked like a little living room with a sofa and other designer touches. We put a 40 x 60-inch frame over the sofa and projected each image into the frame to show the client what their images would look like in a wall-portrait size. After the room was complete, I started practicing how to sell what I had created.

session, they won't book the appointment. This saves you time for productive sessions with clients who will be ordering, and lets the 20 percent of clients who would end up in collections wait until their economic condition improves. It is very cut-and-dry.

Going Digital. When the studio went digital, I saw the perfect opportunity to do away with paper

ed. I hated it and it wasn't easy, but it was necessary if I wanted to make a living in this profession.

I couldn't afford to hire a salesperson at that time, so I did each sales appointment myself. I heard all the complaints that photographers fear. "Why did you pick that background with that clothing?" "How come you charge so much?" "We need to have some-

thing to take home!" I heard them all. But hearing what my clients had to say made two things happen. First of all, I started to put more effort into my sessions, realizing I would be the one to face my clients with the images I had created. I learned how to coordinate the colors, lines, textures, and styles of the background or scenes with the client's clothing. I wanted to able to explain why I selected the background I did. I wanted to be able to show my clients that I was as good as I thought I was.

The second lesson I learned is that when clients are confronted with the reality of purchasing an item they don't really have the money for, but they really want, they will come up with all kinds of little problems to avoid buying the item right then. People buy cars, clothing, jewelry and, yes, portraits everyday using money they don't actually have. They complain, they stall, they come up with every reason why they shouldn't buy what is being sold, but salespeople make the sales in spite of these objections.

Once I learned to sell, I consistently sold wall portraits, which I never had done with paper proofs. My orders were larger, and at least half of the money was in my pocket as we concluded our business, which was the first time the client saw the portraits. Clients were well informed of the procedures of the studio; if they weren't ready to order, they wouldn't make an appointment. I lost some appointments (not having paper proofs), but the majority of those clients would have fallen into the 20 percent that ended up where neither they nor I wanted to go.

With digital, we couldn't sell in the same way we had in our first studio. We have too many seniors, in too short a time frame—and the space for multiple living-room areas wouldn't be feasible at our current location (although the studio is 6600 square feet). To

Once I learned to sell, I consistently sold wall portraits, which I never had done with paper proofs.

As a professional, you simply help your client make the decision that is in their best interests—even if they don't realize it at the time.

simplify the sales process, we created sales rooms where clients view their images on large computer monitors after the session is over. The sales process is the same as it was in the beginning. They first decide on the pose or poses they will select. Once the images are narrowed down to their eight favorite poses (which is also the number of images in the standard folio), they are taken to a separate sales room to go over the packages. Once the package is decided on, they are brought back into the viewing room to fill their package with the eight selected images.

Learning How to Sell. Learning to sell your work is nothing more than learning how humans make decisions. As a professional, you simply help your client make the decision that is in their best interests—even if they don't realize it at the time. There are actually many benefits to clients when ordering portraits in this fashion.

For example, when paper proofs go home, the buyer (typically the wife or mother) normally has the man in her life help her select the portraits—and we all know how helpful men are when making decisions about something they aren't that interested in. "I don't care. They all look the same to me. How much is this going to cost us anyway?" is usually all the help the client will receive. When they view their images immediately after the session, on the other hand, the client has a professional staff there to assist them in every step of the buying process. My sales staff is trained to help clients by pointing out the subtle differences between poses that appear almost the same. In a matter of seconds, they can show the client what an image will look like in black & white or with other finishing touches. They can show a selection of frames that will coordinate with both their home and the portrait. This is a professional way of selling a profes-

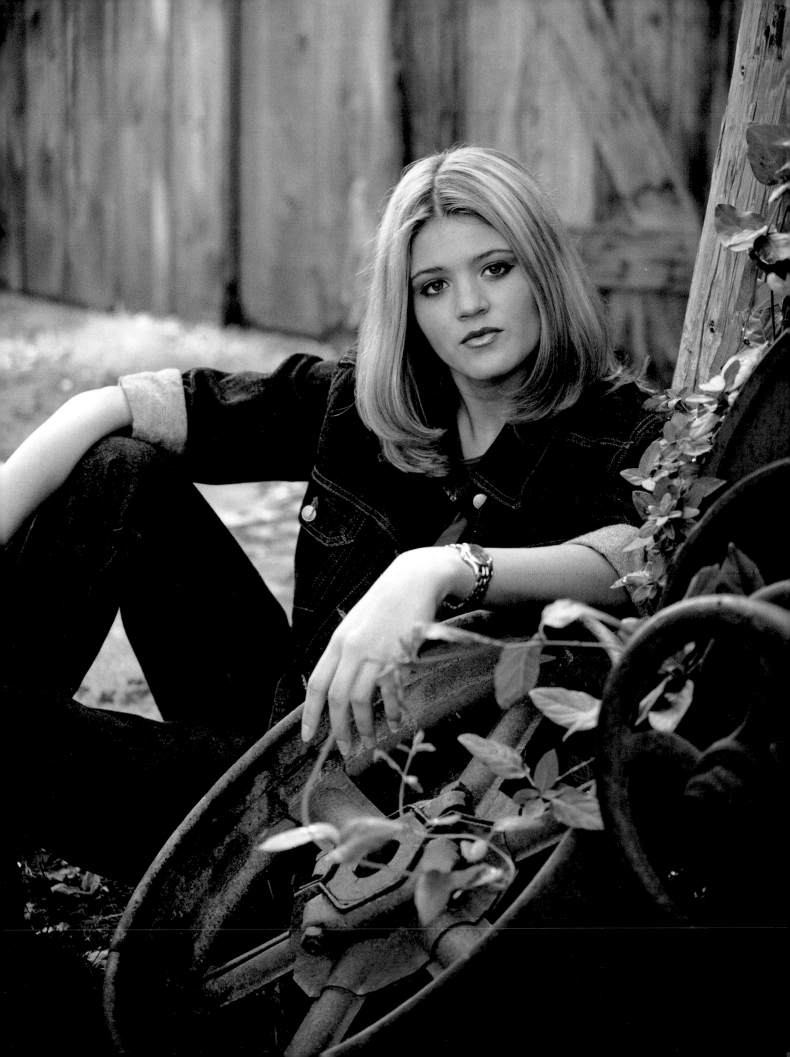

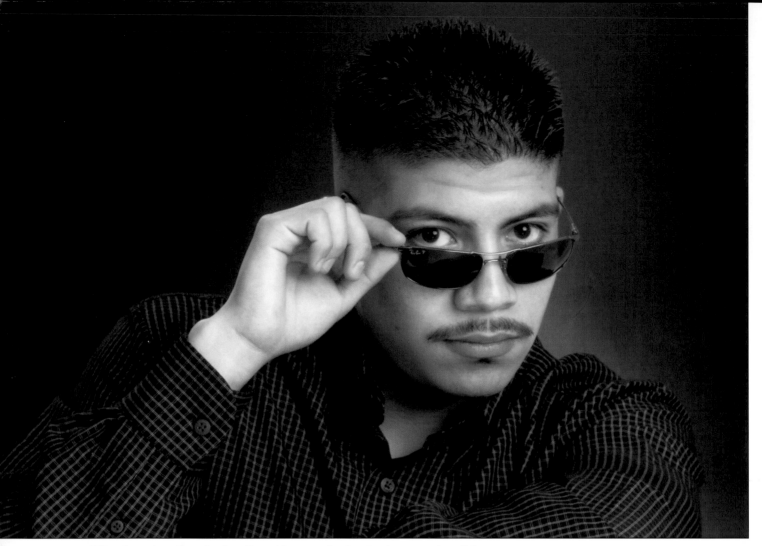

Either learn to sell professionally or hire a professional salesperson to sell for you.

sional product. This isn't your average "run and hide and hope for the best" approach.

If you are considering this approach to sales, let me make two suggestions. First, realize that people can only make one decision at a time. They can't decide on poses, a package, and framing all at once. It is a step-by-step process. First, they select the image or images (with families we narrow it down to one, for seniors we narrow down to eight) they will be ordering from. The next step for families is to have them select a wall-portrait size they feel the most comfortable with. Since the viewing screen is of a fixed size, we use sample photographs in the studio to show the options. This doesn't have quite the impact of seeing the actual portrait in the various sizes, but it helps educate the client about the importance of selecting

the proper size portrait for the room in which it will be displayed. It also lets them see the size of the faces in each print size. After the size of the wall portrait is selected, they decide on a package or number of portraits they need for themselves and their family. Then they fill the packages with the selected image (or images). The final step is to discuss frames, folios, and add-on items that increase the size of the total order without reducing the print sales, which are more profitable.

My second suggestion is that you take selling seriously. Either learn to sell professionally or hire a professional salesperson to sell for you. Make sure their sales experience is with a professional product (not with cars, vacuums, or other "high-pressure" items). If you decide you will do the sales presentation your-

self, then select books and tapes that teach *professional* selling—again, not *high-pressure* selling.

When I first attempted this type of selling, I was scared to death. My first sales appointment was a little rough. I stuttered, I said the wrong things at the wrong times, but I sold a 20 x 24- and two 16 x 20-inch prints to the parents of two smaller children. Up to this point I had never sold anything larger than a 16 x 20, and I had never sold multiple wall portraits from the same session. This made me a believer in selling a product, rather than letting something of great value leave my business and hoping for its return.

▷ Printing and Delivery

Whether you print your own work out or send it to a lab, you are ultimately responsible for the way in which your product is given to your client. This is critical to developing a successful photographic style. You must determine the way in which you want your work to appear in the final product. Do your clients tend to like a true skin tone or a rich skin tone? How much control do you have over the consistency of your work?

Printing. I never realized, until we put in our own digital lab, how inconsistent prints from an outside lab can be. I look at some of the last printing we received from our old lab and I wonder what I was thinking delivering images that looked like that. (Of course, at the time, I thought it was good, because they produced a more consistent product than the lab before them did.)

Control over lab work is a scary thing. When we thought of putting in our lab, I was scared to death. An outside lab is so easy. But as I have stressed in this book, what is easy isn't always the best way to go—especially when you and your client have to live with the results.

With an "in studio" lab, I sit down with the computer people and say I want this skin tone, I want the retouching to look like this, and this is how you will do it. I then go to the production room each day and

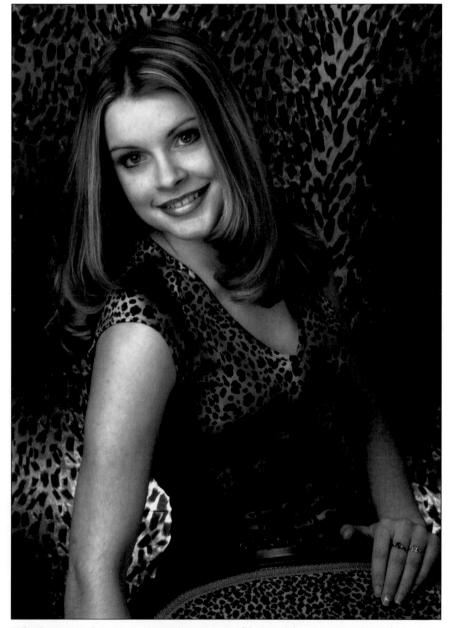

Whether you print your own work out or send it to a lab, you are ultimately responsible for the way in which your product is given to your client.

make sure I'm getting what I want. If it isn't right, I walk it over to the lab and explain again. My work looks better and more consistent than ever before.

There are a few things to think about before printing your own work. First of all, photographers are some frugal people. I know when I talk about printing out my own work, some photographers are thinking "I print out my own work, too—I have my Epson inkjet running all the time!" If you use this type of printer for your clients, it's working, and you're happy with it—that's fine. I prefer to offer my clients the same product they had with film. I want a permanent, durable photograph made on photographic paper, not photo inkjet paper. This is why we purchased a large

photographic processor that uses a CRT to expose photographic paper.

I understand that an in-studio lab isn't an option for some photographers. The startup costs can be high, you need a certain volume of work to make it profitable, and it takes up a considerable amount of space. If an in-studio lab isn't in your future, work closely with your outside lab. The color correction and retouching of your clients' work needs to be very consistent. Should a print not be up to your standards, send it back and make sure it is perfect.

Print Finishing Options. Once your lab can produce the consistent look you desire, then there are other considerations. Do you produce your final

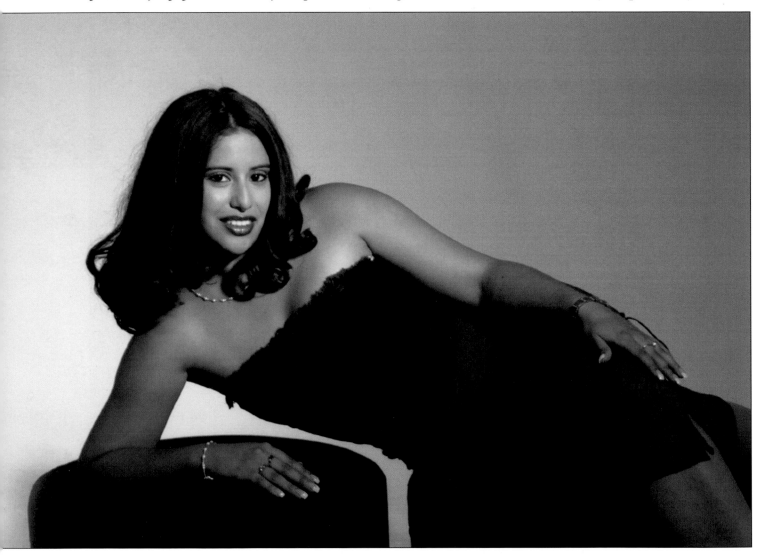

I want a permanent, durable photograph made on photographic paper, not photo inkjet paper.

images on paper or canvas? Do you mount your wall-size portraits and/or do you frame them? Your photographic style is everything that happens from the time you create the image until the image ends up in the client's home.

Some photographers offer canvas printing and framing as additional services, and some insist that a final portrait should not be seen by a client unless it is framed and on canvas. To each his own. This is where business, art, and customer service all have to merge to create a product that is enjoyed for years to come—as well as being salable at a profit.

Working with seniors, we leave canvas as an additional item, while frames are included

A cool product for frames is offered by Levin Frames (www.levinframes.com). It is an easy-to-use program that allows you to drag-and-drop an image into any frame and see exactly what the portrait will look like in that frame.

on some packages and not in others. A cool product for frames is offered by Levin Frames. It is an easy-to-use program that allows you to drag-and-drop an image into any frame and see exactly what the portrait will look like in that frame. It is a powerful sales tool for framing and allows you to order your frames when you order the printing, as opposed to having to stock frames in various sizes.

Packaging. Your product presentation also involves the way you package your product. Do you put loose prints into a manila envelope or do you have boxes, bags, and/or folders to enhance the presentation? Women tend to react more strongly to packaging—and, as noted previously, women tend to be the ones who buy portraits. Personally, I would be happy receiving portraits I purchased in a nice cardboard

photo-mount inside a manila envelope. My wife, however, believes in the Victoria's Secret way of presentation. You can buy the cheapest thing in the store and you still get it wrapped in tissue and put into a cute pink bag. You may be paying seventy-five cents for product and five bucks for the packaging, but women love it. Again, everything that is involved with your product affects the public's opinion about your studio's style.

11. Your Studio's Image

We've just talked about print delivery and how packaging affects your clients' impression of your style. Well, the way you "package" your studio—your marketing, the appearance of your studio, etc.—does precisely the same thing. Obviously, time and energy are at one end of the spectrum and

money is at the other when it comes to putting together a marketing plan. That means you need to make good, well-researched decisions about who you want to appeal to and how to reach them.

▷ Marketing

There are many ways to get your name in front of the people who make up your target market—whatever you determine that market to be. You just have to use the tools that reach the most people in your target market for the least time/energy and money invested. Your marketing strategy will depend on your target market.

While direct mail and a student-ambassador program work well with seniors, you may use a weekly newspaper or newsletter and a referral program for children or families. The choice is yours—but you'll need both resources and imagination.

Misguided Dollars. Once you've decided on the most effective means to get your message out, stick with it. Don't let a salesperson selling radio time,

Working to keep your site new and exciting is important—it's the only way to keep clients interested in visiting.

When you develop a consistent look in your work, advertising, and studio decor, potential clients will be able to quickly gauge what type of portraits you offer and roughly what they can expect to pay.

newspaper ads, or a T-shirt with your company's logo on it talk you into parting with one dollar. If you've decided to put your limited resources into direct mail or a weekly newspaper, that's where you need to spend that money. Don't let some salesperson with the Yellow Pages talk you into a display ad because that's what your competitor is doing.

Many misguided dollars are spent on web sites. A web site is basically a big brochure. Without a reason to look at your brochure (web site), no one will visit. To encourage our seniors to visit our site often, we post new portraits every month, give away trips, etc. Working to keep your site new and exciting is important—it's the only way to keep clients interested in visiting. Even large e-tailers have to constantly advertise their sites to keep people coming back.

If you're good with computers and can design an appealing web site yourself, it's well worth the time invested. If, however, you have to pay top dollar for a designer, your money will probably be better spent elsewhere.

The Two Rules of Marketing. The first rule of marketing is repetition. No matter how well-designed the promotion, your business name must be received between four and six times for the average person to even remember it. Buying one ad, sending one mailer, or securing one radio spot won't fill your appointment book.

The second rule of marketing applies to advertising, and that is: buy in bulk. Many small studios buy mailers one at a time. This means they're paying a premium price. I know photographers who mail out as

No matter what you do, it's going to cost a lot of money—but you'll pay a premium price by purchasing one ad at a time.

many mailers as I do but pay three or four times as much in printing costs, because each mailer is handled job by job. When I send in my mailers, they all go in at once and I get a price of about sixteen cents apiece. This means I don't pay that much more for a 6 x 9-inch color mailer than running black & white copies at a copy shop. The same is true for purchasing ads or airtime. No matter what you do, it's going to cost a lot of money—but you'll pay a premium price by purchasing one ad at a time. Most of the time you can sign a contract for so many ads to run over the next six months or a year and pay for them month by month—and doing just that make more sense for your business.

Mass Advertising. Over the years we've tried radio and television ads and, while it was really cool

hearing and seeing my advertisements, they received little attention from our target market. We've used weekly papers and had moderate success, while daily papers and supplements have been a bust. When we used the Yellow Pages, they charged a small fortune for a display ad, and the potential clients who called only asked one question, "How much do you charge?"

In any mass advertising campaign, you have to study the demographics—the age, sex, and economic status of people that your message will reach. Then you have to look at the actual number of readers, listeners, or viewers each individual station/newspaper has. This is a great deal of work—that's why most people rely upon the advice of the person selling the advertising. Now, that brings us to the golden rule of

advertising (and life): never take advice from someone who's making a commission on what they're selling you. I've seen photographers spend hundreds of dollars on ads in a local weekly paper for their children's portrait services (which the paper has the right demographics for) and then use the same paper for large ads about their high-school senior portraits. Teenagers don't read newspapers and, statistically speaking, the paper is for younger families, so the ads didn't even reach the parents of seniors. The most effective advertising exclusively targets your market. If you have mass appeal like McDonalds, you advertise in mass media. If your clientele is more specific, you must direct your advertising to a smaller group to get the most effective return on the money you invest.

Ask Your Best Clients. If you're going to do any kind of advertising, call the five best clients you've had in the last year (for whatever client type you want to attract). Ask them if they read the newspaper and what radio station they listen to. Also ask whether or not they read single-sheet ads (postcards, larger ads) that come in the mail, or if they'd be more likely to open an envelope and read the ad inside. The questions can go on and on depending on the type of advertising you want to do.

The same can be done for any marketing decisions. Make up a focus group of past clients (although they don't have to meet in a group) and get the needed information from them. They can decide everything from the paint colors for your walls to your business card design, to the language you use in your ads. (We're lucky, because many of our employees are past clients, so we run everything past them to make sure we aren't off the mark. Many times, we've written ads using what we considered trendy sayings, and our younger employees [former senior clients themselves] alerted us to the fact that we sounded like older people trying to be hip.) This way, you're sure that everything in your business is designed to the taste of the client you want to attract.

Many of our employees are past clients, so we run everything past them to make sure we aren't off the mark.

Direct mail is the top choice of photographers who buy advertising, so it's important to know how and why mailers work.

Another good idea is to ask first-time clients how they came upon your studio. This tells you what's working, although many times you have to use this information with a degree of common sense. A client might say she came to your studio after a recent mailing, giving you an idea to increase your mailings, but what really sold her on your studio were some of your past clients, an exhibit you did last year, etc. The mailer just happens to be the last thing she received, and she held on to it to keep your number on hand.

Giving Work Away. An effective way to get your work in front of your target audience is to give away a few free portraits. To do this, find a person who travels in the right circles and get a wall portrait into their home—it really generates sales. This saved me from bankruptcy in those early years. A few words of advice, though. First, be very careful whom you pick. Make

sure you select the leader of whatever pack you're trying to reach. Social events are great places to see the pecking order in a group. You'll want to give your work to someone who will show it off, someone who seems to thrive in a social situation and has many friends. Second, make sure your studio's name and phone number are on every print you give away—no matter the size.

Direct Mail. Direct mail is the top choice of photographers who buy advertising, so it's important to know how and why mailers work. With all the mailers that go out each year, very few photographers have taken the time to study and learn what makes one mailer work, while another doesn't. What makes a client respond to one studio's mailing piece and overlook another? What types of mailers produce phone calls and what types produce potential clients?

In advertising, there are no sure things. Nothing always works. A famous advertising executive said that he figures about half of all of his advertising actually works. If he could only figure out which half it was, he would have something. Regardless, there are many things that can be done to greatly increase the odds of success.

The best way to understand how to produce a better mailer is to understand what each component of a mailer is and how it benefits the response rate of that mailer. To begin, the portraits in a mailer really capture the attention of the viewer. In the sea of mailers, you can't show boring portraits. Then, add a good headline—a short, to-the-point bit of text—to entice the viewer to read the copy and find out why they should select your studio. In a mailer that we've used in varying forms for the last six years, the headline

reads, "No . . . they're not professional models!"—the copy explains that they look like they are because they came to our studios.

Next, include a clear statement that explains what makes your product unique in the marketplace and how it can benefit the potential client. If your headline states that your studio provides lots of personal attention, you could go on to explain that your clients have more clothing changes and that you take time to find out what they really want out of the session. You can also reassure them that they won't feel rushed, they'll feel more comfortable because they have time to get to know you before their session, etc. The copy also needs to explain what the client needs to do. If you do consultations, explain how the client can schedule one. In our case we have a consultation CD, so in our copy we invite the senior to come in and take

The best way to understand how to produce a better mailer is to understand what each component of a mailer is and how it benefits the response rate of that mailer.

one home. During their visit they can also look through the hundreds of sample senior portraits to make sure that we offer the style of senior portraits they are looking for.

Your logo is the most important part of your mailer. If every other part of your mailer is perfect, but you forget your logo—or if your logo is hard to read—the phone won't ring. A logo doesn't have to be anything more than your studio's name set in a distinctive typestyle. And remember—keep everything legible. If potential clients can't read your mailer easily, they won't read it all. Keep the type clean and crisp.

Your studio hours should also be listed in your mailer. How many times have you gotten a piece of advertising with no hours listed on it? Then you call the company that sent the ad only to find they don't have a recording that states the hours. You have to keep calling back until you reach someone. A person might do this for a once-a-year sale, but they won't do it in an overcrowded market like portraiture.

Create a Theme. As I mentioned earlier, it takes four to six separate messages for the average person to remember your name and call you when they have a need for what you're selling. Your name alone will not be remembered unless you have a common theme that ties all your messages together—think back to our discussion of the importance of consistency in your portraits; it's the same concept. Uneducated advertisers design their ads one piece at a time and do nothing to link those pieces together; savvy advertisers work on designing a *campaign* (many advertising

It takes four to six separate messages for the average person to remember your name and call you when they have a need for what you're selling.

messages tied together with a common theme). The flavor of the campaign will communicate your style to your target audience.

A common theme doesn't mean saying the exact same thing in every ad, but linking the look and feel of each advertisement together, so when the person gets the mailer their mind links the current mailer with the one they've already seen. One of the easiest ways to make a connection between your mailers is to use the same people in the mailers, with different poses. You can use the same-size mailers (don't use more than two sizes and styles of mailer) or use similar borders around the portraits and similar accents in each mailer.

Tailor Your Marketing to Your Image. Every part of your marketing plan should suit your business's image and be geared toward the segment of the market you want to attract. Your greatest marketing efforts should be directed toward the market that gives you the highest return on your time and money invested. Whatever choices you make, base your decisions on where you want to be and the most effective means to get you there. You have to define what success is to you. You can't get where you want to be if you don't know the destination you want to reach. Of this I am sure. No person who takes the time to decide on a goal is without the ability to reach it. Once you commit to a goal, you develop a passion for its completion. You become almost dissatisfied with the way things are. That outlook will help you overcome all the obstacles you are sure to face.

▷ Your Studio

In any business, you must create an image that reflects the tastes of your target market. Everything from the message contained in your radio ad, to the color scheme you use in your print advertising, to the interior of your studio must suit your clientele. The portraits you display in your studio and the music you

The decor of our studio sets the tone for the images we create—it instantly lets people know what to expect.

have playing in the background must also appeal to your target market. By taking these steps, your target market can identify with every part of your business.

When you get really good at this, potential clients should be able to gauge what type of portraits you offer and roughly what they can expect to pay—at a glance. The images displayed on the ad, the colors you select—even the quality of the printing and the layout—should speak volumes about your studio.

When a person walks into your business, they should know right away whether or not it is right for them. When a potential client walks into our studio, they see nothing but senior portraits. A bride-to-be or mother looking for children's portraits will know right away that she's in the wrong place. The color schemes and furnishings used in the studios are slightly upscale but are modest enough not to scare off any of our

contracted seniors, some of whom have modest budgets. The music is a little louder than in most businesses and is always set on the station that the high school seniors listen to the most.

Most photographers never think about their studios in these terms. They pick out everything according to their personal tastes—without thinking about their clients. Many photographers in a general studio display portraits they like, rather than using their display portraits to help define their business. I have gone into studios that photograph many seniors, but they have nothing but wedding and children's portraits on display. This would be like going into a Chinese restaurant and seeing sombreros and Mexican blankets all around for decoration—it wouldn't make much sense.

Select your decor to match your desired pricing. Many photographers want to charge more for their work, but they have an old, torn sofa in front of their studio that's been there since the '70s. Some studios select furnishings that are too nice, and this can also be a problem. If you walked into a restaurant for a casual, low-cost lunch and saw fine art on the walls, overstuffed chairs at each table, and columns and marble floors as far as the eye could see, your heart would start racing! You'd turn and leave before ever looking at the menu. As a result, you'd never find out that they had good food at reasonable prices.

Every area of the studio reinforces the style and quality of our work.

Conclusion

So, are you a copier or are you a creator? Are you going to learn to forge your own path, or are you going to walk in the shadow of the photographers who are leading the way? Will the images you create age well or will they find their way to your clients' closets—costly mistakes that they will never repeat. Is your approach to a session going to be guided by what's best for the client or what's easiest for you?

I was once a young photographer, scared to death and looking for a way to become more than I was. I looked for answers, and most of the time I had to come up with solutions on my own. My goal in writing this book (and my other books) is to provide some of the answers I was looking for—the things I wish I'd known when I was starting out.

Photography can be an extremely rewarding career—both creatively and financially. If you keep in mind the lessons in this book and put your clients first in all your decisions, you'll be well on your way to building a successful business!

Index

LIGHTING FOR PEOPLE PHOTOGRAPHY, 2nd Ed.

Stephen Crain

A guide to lighting for portraiture. Includes setups, equipment information, strobe and natural lighting, and much more! Features diagrams, illustrations, and exercises for practicing the techniques discussed in each chapter. $29.95 list, 8½x11, 120p, 80 b&w and color photos, glossary, index, order no. 1296.

WEDDING PHOTOGRAPHY
CREATIVE TECHNIQUES FOR LIGHTING, POSING, AND MARKETING, 3rd Ed.

Rick Ferro

Creative techniques for lighting and posing wedding portraits that will set your work apart from the competition. Covers every phase of wedding photography. $29.95 list, 8½x11, 128p, 125 color photos, index, order no. 1649.

STUDIO PORTRAIT PHOTOGRAPHY OF CHILDREN AND BABIES, 2nd Ed.

Marilyn Sholin

Work with the youngest portrait clients to create cherished images. Includes techniques for working with kids at every developmental stage, from infant to preschooler. $29.95 list, 8½x11, 128p, 90 color photos, order no. 1657.

PROFESSIONAL SECRETS OF WEDDING PHOTOGRAPHY, 2nd Ed.

Douglas Allen Box

Top-quality portraits are analyzed to teach you the art of professional wedding portraiture. Lighting diagrams, posing information, and technical specs are included for every image. $29.95 list, 8½x11, 128p, 80 color photos, order no. 1658.

PHOTO RETOUCHING WITH ADOBE® PHOTOSHOP®, 2nd Ed.

Gwen Lute

Teaches every phase of the process, from scanning to final output. Learn to restore damaged photos, correct imperfections, create realistic composite images, and correct for dazzling color. $29.95 list, 8½x11, 120p, 100 color images, order no. 1660.

CREATIVE LIGHTING TECHNIQUES FOR STUDIO PHOTOGRAPHERS, 2nd Ed.

Dave Montizambert

Whether you are shooting portraits, cars, tabletop, or any other subject, Dave Montizambert teaches you the skills you need to take complete control of your lighting. $29.95 list, 8½x11, 120p, 80 color photos, order no. 1666.

POSING AND LIGHTING TECHNIQUES FOR STUDIO PHOTOGRAPHERS

J. J. Allen

Master the skills you need to create beautiful lighting for portraits. Posing techniques for flattering, classic images help turn every portrait into a work of art. $29.95 list, 8½x11, 120p, 125 color photos, order no. 1697.

PROFESSIONAL SECRETS OF
NATURAL LIGHT PORTRAIT PHOTOGRAPHY

Douglas Allen Box

Use natural light to create hassle-free portraiture. Beautifully illustrated with detailed instructions on equipment, lighting, and posing. $29.95 list, 8½x11, 128p, 80 color photos, order no. 1706.

PORTRAIT PHOTOGRAPHER'S HANDBOOK, 2nd Ed.

Bill Hurter

Bill Hurter has compiled a step-by-step guide to portraiture that easily leads the reader through all phases of portrait photography. This book will be an asset to experienced photographers and beginners alike. $29.95 list, 8½x11, 128p, 175 color photos, order no. 1708.

PROFESSIONAL MARKETING & SELLING TECHNIQUES
FOR WEDDING PHOTOGRAPHERS

Jeff Hawkins and Kathleen Hawkins

Learn the business of wedding photography. Includes consultations, direct mail, advertising, internet marketing, and much more. $29.95 list, 8½x11, 128p, 80 color photos, order no. 1712.

Other Books by Jeff Smith . . .

POSING FOR PORTRAIT PHOTOGRAPHY
A HEAD-TO-TOE GUIDE

For most photographers, learning to create flattering poses is more difficult to learn than lighting. In this book, you'll learn what makes a pose work, how to tailor poses to the individual, and how to make posing a selling point in your portraits. $29.95 list, 8½x11, 128p, 150 color photos, index, order no. 1786.

SUCCESS IN PORTRAIT PHOTOGRAPHY

Unfortunately, many portrait photographers realize too late that camera skills alone do not ensure the financial success of their business. This practical guide will teach professional photographers how to run savvy marketing campaigns, attract the types of clients they want, and provide top-notch customer service. $29.95 list, 8½x11, 128p, 100 color photos, order no. 1748.

CORRECTIVE LIGHTING AND POSING TECHNIQUES FOR PORTRAIT PHOTOGRAPHERS

Learn to make every client look his or her best by using lighting and posing to conceal real or imagined flaws—from baldness, to acne, to figure flaws. $29.95 list, 8½x11, 120p, 150 color photos, order no. 1711.

OUTDOOR AND LOCATION PORTRAIT PHOTOGRAPHY, 2nd Ed.

Learn to work with natural light, select locations, and make clients look their best. Packed with step-by-step discussions and illustrations to help you shoot like a pro! $29.95 list, 8½x11, 128p, 80 color photos, index, order no. 1632.

PROFESSIONAL DIGITAL PORTRAIT PHOTOGRAPHY

Because the learning curve is so steep, making the transition to digital can be frustrating for portrait photographers. Author Jeff Smith shows readers how to shoot, edit, and retouch their images—while avoiding common pitfalls. $29.95 list, 8½x11, 128p, 100 color photos, order no. 1750.

PHOTOGRAPHERS AND THEIR STUDIOS
CREATING AN EFFICIENT AND PROFITABLE WORKSPACE
Helen T. Boursier

Tour professional studios and learn creative solutions for common problems. $29.95 list, 8½x11, 128p, 100 color photos, order no. 1713.

TRADITIONAL PHOTOGRAPHIC EFFECTS WITH ADOBE® PHOTOSHOP®, 2nd Ed.
Michelle Perkins and Paul Grant

Use Photoshop to enhance your photos with handcoloring, vignettes, soft focus, and much more. Step-by-step instructions are included for each technique for easy learning. $29.95 list, 8½x11, 128p, 150 color images, order no. 1721.

MASTER POSING GUIDE FOR PORTRAIT PHOTOGRAPHERS
J. D. Wacker

Learn the techniques you need to pose single portrait subjects, couples, and groups for studio or location portraits. Includes techniques for photographing weddings, teams, children, special events, and much more. $29.95 list, 8½x11, 128p, 80 photos, order no. 1722.

THE ART OF BRIDAL PORTRAIT PHOTOGRAPHY
Marty Seefer

Learn to give every client your best and create timeless images that are sure to become family heirlooms. Seefer takes readers through every step of the bridal shoot, ensuring flawless results. $29.95 list, 8½x11, 128p, 70 color photos, order no. 1730.

PHOTOGRAPHER'S FILTER HANDBOOK

Stan Sholik and Ron Eggers

Take control of your photography with the tips offered in this book! This comprehensive volume teaches readers how to color-balance images, correct contrast problems, create special effects, and more. $29.95 list, 8½x11, 128p, 100 color photos, order no. 1731.

BEGINNER'S GUIDE TO ADOBE® PHOTOSHOP®, 2nd Ed.

Michelle Perkins

Learn to effectively make your images look their best, create original artwork, or add unique effects to any image. Topics are presented in short, easy-to-digest sections that will boost confidence and ensure outstanding images. $29.95 list, 8½x11, 128p, 300 color images, order no. 1732.

PROFESSIONAL TECHNIQUES FOR DIGITAL WEDDING PHOTOGRAPHY, 2nd Ed.

Jeff Hawkins and Kathleen Hawkins

From selecting equipment, to marketing, to building a digital workflow, this book teaches how to make digital work for you. $29.95 list, 8½x11, 128p, 85 color images, order no. 1735.

LIGHTING TECHNIQUES FOR HIGH KEY PORTRAIT PHOTOGRAPHY

Norman Phillips

Learn to meet the challenges of high key portrait photography and produce images your clients will adore. $29.95 list, 8½x11, 128p, 100 color photos, order no. 1736.

PROFESSIONAL DIGITAL PHOTOGRAPHY

Dave Montizambert

From monitor calibration, to color balancing, to creating advanced artistic effects, this book provides those skilled in basic digital imaging with the techniques they need to take their photography to the next level. $29.95 list, 8½x11, 128p, 120 color photos, order no. 1739.

GROUP PORTRAIT PHOTOGRAPHY HANDBOOK

Bill Hurter

Featuring over 100 image images by top photographers, this book offers practical techniques for composing, lighting, and posing group portraits—whether in the studio or on location. $29.95 list, 8½x11, 128p, 120 color photos, order no. 1740.

LIGHTING AND EXPOSURE TECHNIQUES FOR OUTDOOR AND LOCATION PORTRAIT PHOTOGRAPHY

J. J. Allen

Meet the challenges of changing light and complex settings with techniques that help you achieve great images every time. $29.95 list, 8½x11, 128p, 150 color photos, order no. 1741.

THE ART AND BUSINESS OF HIGH SCHOOL SENIOR PORTRAIT PHOTOGRAPHY

Ellie Vayo

Learn the techniques that have made Ellie Vayo's studio one of the most profitable senior portrait businesses in the U.S. $29.95 list, 8½x11, 128p, 100 color photos, order no. 1743.

THE ART OF BLACK & WHITE PORTRAIT PHOTOGRAPHY

Oscar Lozoya

Learn how master photographer Oscar Lozoya uses unique sets and engaging poses to create black & white portraits that are infused with drama. Includes lighting strategies, special shooting techniques, and more. $29.95 list, 8½x11, 128p, 100 duotone photos, order no. 1746.

THE BEST OF WEDDING PHOTOGRAPHY

Bill Hurter

Learn how the top wedding photographers in the industry transform special moments into lasting romantic treasures with the posing, lighting, album design, and customer service pointers found in this book. $29.95 list, 8½x11, 128p, 150 color photos, order no. 1747.

THE BEST OF CHILDREN'S PORTRAIT PHOTOGRAPHY

Bill Hurter

Rangefinder editor Bill Hurter draws upon the experience and work of top professional photographers, uncovering the creative and technical skills they use to create their magical portraits of these young subejcts. $29.95 list, 8½x11, 128p, 150 color photos, order no. 1752.

WEDDING PHOTOGRAPHY WITH ADOBE® PHOTOSHOP®

Rick Ferro and Deborah Lynn Ferro

Get the skills you need to make your images look their best, add artistic effects, and boost your wedding photography sales with savvy marketing ideas. $29.95 list, 8½x11, 128p, 100 color images, index, order no. 1753.

WEB SITE DESIGN FOR PROFESSIONAL PHOTOGRAPHERS

Paul Rose and Jean Holland-Rose

Learn how to design, maintain, and update your own photography web site—attracting new clients and boosting your sales. $29.95 list, 8½x11, 128p, 100 color images, index, order no. 1756.

PROFESSIONAL PHOTOGRAPHER'S GUIDE TO
SUCCESS IN PRINT COMPETITION

Patrick Rice

Learn from PPA and WPPI judges how you can improve your print presentations and increase your scores. $29.95 list, 8½x11, 128p, 100 color photos, index, order no. 1754.

PHOTOGRAPHER'S GUIDE TO
WEDDING ALBUM DESIGN AND SALES

Bob Coates

Enhance your income and creativity with these techniques from top wedding photographers. $29.95 list, 8½x11, 128p, 150 color photos, index, order no. 1757.

PROFESSIONAL TECHNIQUES FOR
PET AND ANIMAL PHOTOGRAPHY

Debrah H. Muska

Adapt your portrait skills to meet the challenges of pet photography, creating images for both owners and breeders. $29.95 list, 8½x11, 128p, 110 color photos, index, order no. 1759.

THE BEST OF PORTRAIT PHOTOGRAPHY

Bill Hurter

View outstanding images from top professionals and learn how they create their masterful images. Includes techniques for classic and contemporary portraits. $29.95 list, 8½x11, 128p, 200 color photos, index, order no. 1760.

THE ART AND TECHNIQUES OF
BUSINESS PORTRAIT PHOTOGRAPHY

Andre Amyot

Learn the business and creative skills photographers need to compete successfully in this challenging field. $29.95 list, 8½x11, 128p, 100 color photos, index, order no. 1762.

THE BEST OF TEEN AND SENIOR PORTRAIT PHOTOGRAPHY

Bill Hurter

Learn how top professionals create stunning images that capture the personality of their teen and senior subjects. $29.95 list, 8½x11, 128p, 150 color photos, index, order no. 1766.

PHOTOGRAPHER'S GUIDE TO
THE DIGITAL PORTRAIT
START TO FINISH WITH ADOBE® PHOTOSHOP®

Al Audleman

Follow through step-by-step procedures to learn the process of digitally retouching a professional portrait. $29.95 list, 8½x11, 128p, 120 color images, index, order no. 1771.

THE PORTRAIT BOOK
A GUIDE FOR PHOTOGRAPHERS

Steven H. Begleiter

A comprehensive textbook for those getting started in professional portrait photography. Covers every aspect from designing an image to executing the shoot. $29.95 list, 8½x11, 128p, 130 color images, index, order no. 1767.

DIGITAL PHOTOGRAPHY FOR CHILDREN'S AND FAMILY PORTRAITURE

Kathleen Hawkins

Discover how digital photography can boost your sales, enhance your creativity, and improve your studio's workflow. $29.95 list, 8½x11, 128p, 130 color images, index, order no. 1770.

PROFESSIONAL STRATEGIES AND TECHNIQUES FOR DIGITAL PHOTOGRAPHERS

Bob Coates

Learn how professionals—from portrait artists to commercial specialists—enhance their images with digital techniques. $29.95 list, 8½x11, 128p, 130 color photos, index, order no. 1772.

LIGHTING TECHNIQUES FOR
LOW KEY PORTRAIT PHOTOGRAPHY

Norman Phillips

Learn to create the dark tones and dramatic lighting that typify this classic portrait style. $29.95 list, 8½x11, 128p, 100 color photos, index, order no. 1773.

THE BEST OF WEDDING PHOTOJOURNALISM

Bill Hurter

Learn how top professionals capture these fleeting moments of laughter, tears, and romance. Features images from over twenty renowned wedding photographers. $29.95 list, 8½x11, 128p, 150 color photos, index, order no. 1774.

THE DIGITAL DARKROOM GUIDE WITH ADOBE® PHOTOSHOP®

Maurice Hamilton

Bring the skills and control of the photographic darkroom to your desktop with this complete manual. $29.95 list, 8½x11, 128p, 140 color images, index, order no. 1775.

COLOR CORRECTION AND ENHANCEMENT WITH ADOBE® PHOTOSHOP®

Michelle Perkins

Master precision color correction and artistic color enhancement techniques for scanned and digital photos. $29.95 list, 8½x11, 128p, 300 color images, index, order no. 1776.

FANTASY PORTRAIT PHOTOGRAPHY

Kimarie Richardson

Learn how to create stunning portraits with fantasy themes—from fairies and angels, to 1940s glamour shots. Includes portrait ideas for infants through adults. $29.95 list, 8½x11, 128p, 60 color photos index, order no. 1777.

PORTRAIT PHOTOGRAPHY

THE ART OF SEEING LIGHT

Don Blair with Peter Skinner

Learn to harness the best light both in studio and on location, and get the secrets behind the magical portraiture captured by this award-winning, seasoned pro. $29.95 list, 8½x11, 128p, 100 color photos, index, order no. 1783.

PLUG-INS FOR ADOBE® PHOTOSHOP®

A GUIDE FOR PHOTOGRAPHERS

Jack and Sue Drafahl

Supercharge your creativity and mastery over your photography with Photoshop and the tools outlined in this book. $29.95 list, 8½x11, 128p, 175 color photos, index, order no. 1781.

POWER MARKETING FOR WEDDING AND PORTRAIT PHOTOGRAPHERS

Mitche Graf

Set your business apart and create clients for life with this comprehensive guide to achieving your professional goals. $29.95 list, 8½x11, 128p, 100 color images, index, order no. 1788.

BEGINNER'S GUIDE TO ADOBE® PHOTOSHOP® ELEMENTS®

Michelle Perkins

Packed with easy lessons for improving virtually every aspect of your images—from color balance, to creative effects, and more. $29.95 list, 8½x11, 128p, 300 color images, index, order no. 1790.

BEGINNER'S GUIDE TO PHOTOGRAPHIC LIGHTING

Don Marr

Create high-impact photographs of any subject with Marr's simple techniques. From edgy and dynamic to subdued and natural, this book will show you how to get the myriad effects you're after. $29.95 list, 8½x11, 128p, 150 color photos, index, order no. 1785.

PROFESSIONAL MODEL PORTFOLIOS

A STEP-BY-STEP GUIDE FOR PHOTOGRAPHERS

Billy Pegram

Learn how to create dazzling portfolios that will get your clients noticed—and hired! $29.95 list, 8½x11, 128p, 100 color images, index, order no. 1789.

THE PORTRAIT PHOTOGRAPHER'S GUIDE TO POSING

Bill Hurter

Posing can make or break an image. Now you can get the posing tips and techniques that have propelled the finest portrait photographers in the industry to the top. $29.95 list, 8½x11, 128p, 200 color photos, index, order no. 1779.

MASTER LIGHTING GUIDE

FOR PORTRAIT PHOTOGRAPHERS

Christopher Grey

Efficiently light executive and model portraits, high and low key images, and more. Master traditional lighting styles and use creative modifications that will maximize your results. $29.95 list, 8½x11, 128p, 300 color photos, index, order no. 1778.

PROFESSIONAL DIGITAL
IMAGING FOR WEDDING AND
PORTRAIT PHOTOGRAPHERS
Patrick Rice

Build your business and enhance your creativity with practical strategies for making digital work for you. $29.95 list, 8½x11, 128p, 200 color photos, index, order no. 1780.

STUDIO LIGHTING
A PRIMER FOR PHOTOGRAPHERS
Lou Jacobs Jr.

Get started in studio lighting. Jacobs outlines equipment needs, terminology, lighting setups and much more, showing you how to create top-notch portraits and still lifes. $29.95 list, 8½x11, 128p, 190 color photos index, order no. 1787.

CLASSIC PORTRAIT
PHOTOGRAPHY
William S. McIntosh

Learn how to create portraits that truly stand the test of time. Master photographer Bill McIntosh discusses some of his best images, giving you an inside look at his timeless style. $29.95 list, 8½x11, 128p, 100 color photos, index, order no. 1784.

DIGITAL INFRARED
PHOTOGRAPHY
Patrick Rice

The dramatic look of infrared photography has long made it popular—but with digital it's actually *easy* too! Add digital IR to your repertoire with this comprehensive book. $29.95 list, 8½x11, 128p, 100 b&w and color photos, index, order no. 1792.

THE BEST OF DIGITAL
WEDDING PHOTOGRAPHY
Bill Hurter

Explore the groundbreaking images and techniques that are shaping the future of wedding photography. Includes dazzling photos from over 35 top photographers. $29.95 list, 8½x11, 128p, 175 color photos, index, order no. 1793.

LIGHTING TECHNIQUES FOR
FASHION AND GLAMOUR
PHOTOGRAPHY
Stephen A. Dantzig, PsyD.

In fashion and glamour photography, light is the key to producing images with impact. With these techniques, you'll be primed for success! $29.95 list, 8½x11, 128p, over 200 color images, index, order no. 1795.

WEDDING AND PORTRAIT
PHOTOGRAPHERS'
LEGAL HANDBOOK
N. Phillips and C. Nudo, Esq.

Don't leave yourself exposed! Sample forms and practical discussions help you protect yourself and your business. $29.95 list, 8½x11, 128p, 25 sample forms, index, order no. 1796.

PROFESSIONAL TECHNIQUES FOR
BLACK & WHITE
DIGITAL PHOTOGRAPHY
Patrick Rice

Digital makes it easier than ever to create black & white images. With these techniques, you'll learn to achieve dazzling results! $29.95 list, 8½x11, 128p, 100 color photos, index, order no. 1798.

The Practical Guide to
Digital Imaging
Michelle Perkins

This book takes the mystery (and intimidation!) out of digital imaging. Short, simple lessons make it easy to master all the terms and techniques. $29.95 list, 8½x11, 128p, 150 color images, index, order no. 1799.